Edited by Alice Rose George and Lee Marks

Hope
Photographs

With Essays by
Robert Coles
Reynolds Price
Lionel Tiger

Thames and Hudson

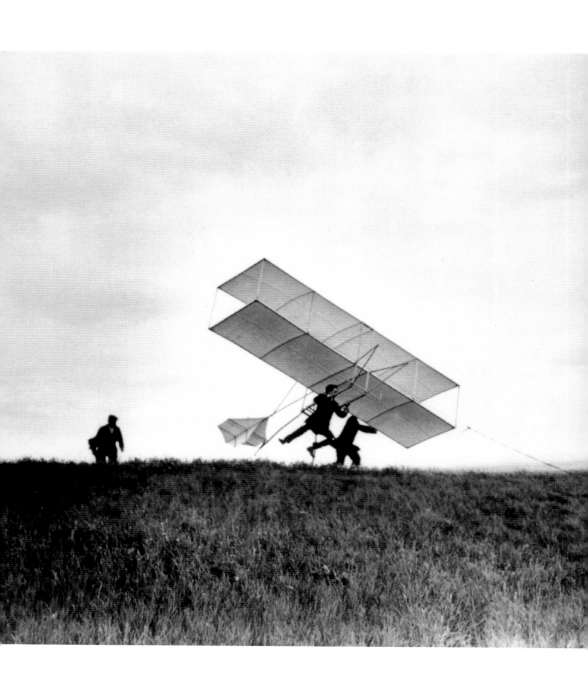

Jacques-Henri Lartigue |
The ZYX 24 takes off. Piroux, Zissou, George, Louis, Dédé and Robert try to take off, too. Rouzat, 1910

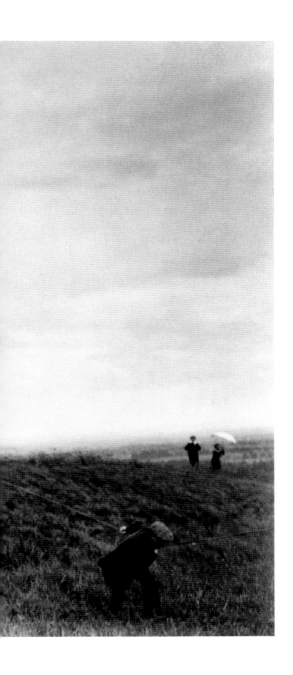

Contents

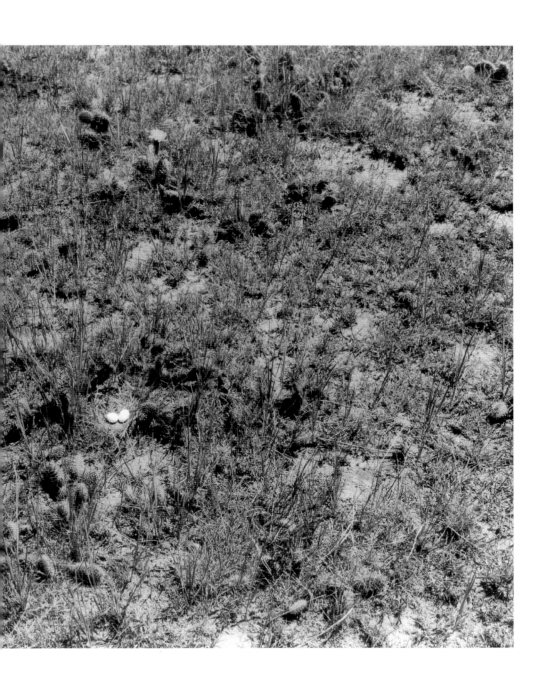

Robert Adams | Dove Eggs, The Pawnee Grasslands, Colorado, 1984 **7**

Introduction

Hope is a word we have known from the beginning. Even before the word, hope has been with us as an instinct, a feeling, an impulse, a thought. We know it so well, yet we forget what an important role it plays in every aspect of our being.

So often, we are overwhelmed by news of war, genocide and corruption. Despite outrage over the devastation inherent in each of these situations, we feel that the weight of negativism and despair in the telling—however valid—does not always present the total picture. If it did, how could mankind continue when there seems to be nothing but hopelessness? We began to look for images in contemporary photography that reflected the opposite of despair, believing that instances of cooperation and harmony are far more common than the proliferation of negative images would suggest and that expectations occur unconsciously in the daily lives of ordinary people.

A belief that we have value, that humanity has nobility despite evil acts, was the guiding principle in assembling this collection of photographs. We wanted to remind ourselves "that man will not merely endure; he will prevail," as William Faulkner said in his Nobel Prize acceptance speech in 1949.

With Jacques-Henri Lartigue's 1910 photograph of childhood invention as a springboard, we were challenged to find images of hope from our times—the second half of the twentieth century, the end of the millennium—encumbered as it is with doubt and cynicism. We wanted to see, without sentimentality, this thing called hope that gets us out of bed in the morning and makes us believe we can do the most mundane and the most impossible tasks. We looked at the work of both art and documentary photographers. Acknowledging that we live in a pluralist society and that our existence is measured in global dimensions, we recognized the importance of giving this visual essay international scope.

We started with the belief that the act of creation—photography, in this case—is an act of hope. Certain general themes began emerging in the selection of photographs. One was the sense that hope is

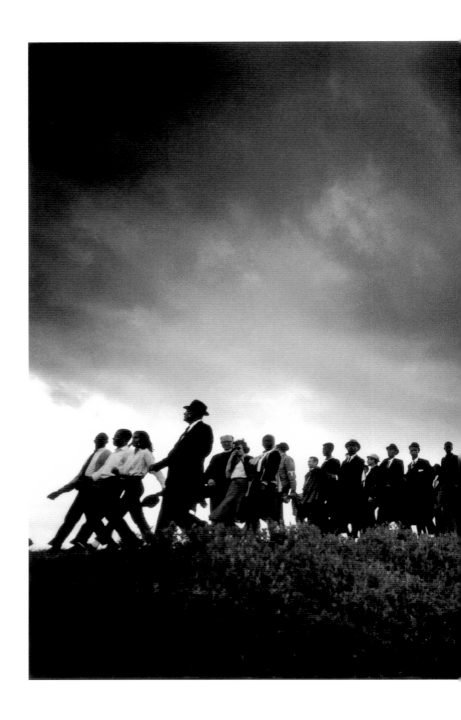

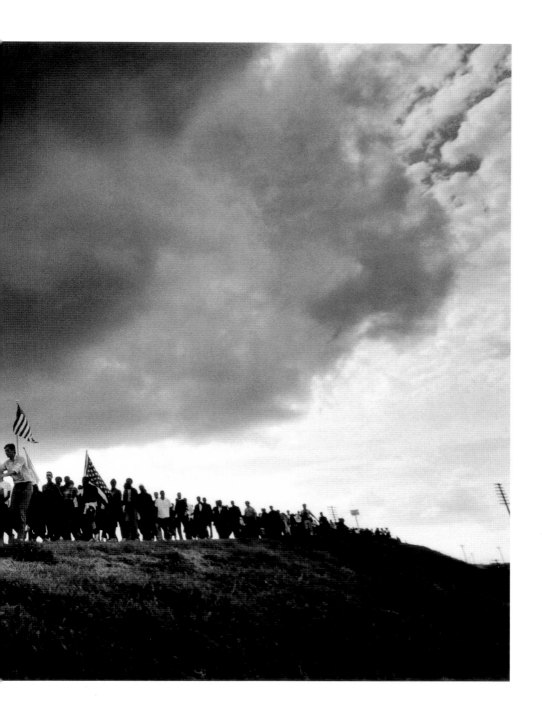

James H. Karales | Marchers, Selma to Montgomery, Alabama, 1965

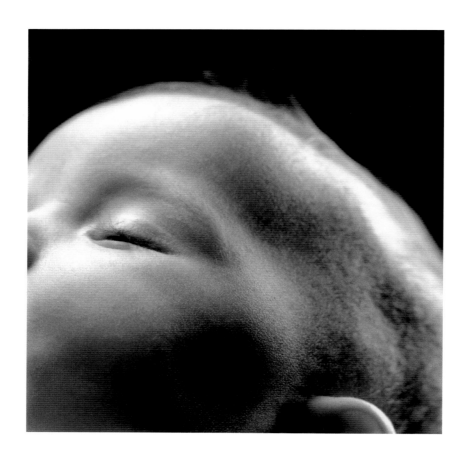

Mario Cravo Neto | Akira (head), 1992

future-oriented. This idea could be as simple as catching the football in Geoffrey Winningham's photograph or as poignantly complex as Witold Krassowski's image of the Rwandan tailor, adhering to his routine amidst total devastation, planning for what could only be the most precarious of futures. Hope is also dynamic. Whereas hopelessness often results in inertia, hope is a spur to action. Many of the images in the collection are about *doing* rather than merely *being*. Finally, hope and photography share a common characteristic — light. In the photographs of Richard Misrach, Hiroshi Sugimoto, and NASA's Hubble Space Telescope (Jeff Hester), the subject matter of light represents hope in its most sublime form.

While we found hope where we might have envisioned it — birth, childhood, education, invention, exploration, science, the arts, communication, romance, sports, risk-taking, and religion — we also tracked it down in unexpected places. We discovered the hope that can be part of death in Alex Harris's image of flowers springing from a grave and in the visual fable Duane Michals relates in "Grandpa Goes to Heaven." Even in the hopelessness of a disease such as AIDS, we saw hope in Nicholas Nixon's image of Tom Moran — the disease already beginning to reveal the outline of his backbone — boldly facing his future by the simple action of raising his hand to a window washed by light. And we found fragments of hope even in the midst of disaster. Armed only with hope, Rosalind Solomon's Midwest flood victims prepare to begin life again with a few photographs and a pair of living room lamps. In a ravaged Chechnya, Anthony Suau discovered a man who had carefully set a table to dine amidst rubble, in a dining room with no wall or ceiling and furnished solely by his determination.

After the collection was assembled, three noted authors and educators — Robert Coles, Reynolds Price and Lionel Tiger — looked at the photographs and responded to the images in their own language. They found hope to be an instrument of survival, a gift to be passed from generation to generation, a biological reality and vital bias.

Alice Rose George and Lee Marks
Co-Curators

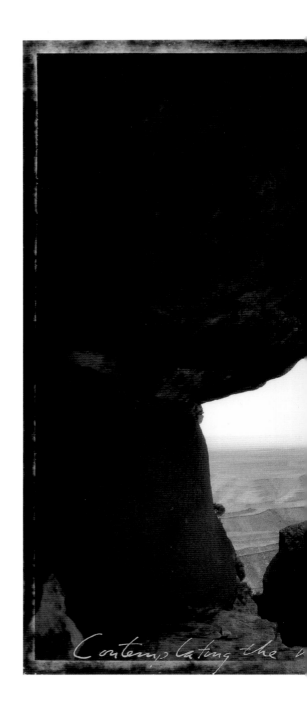

Contemplating the

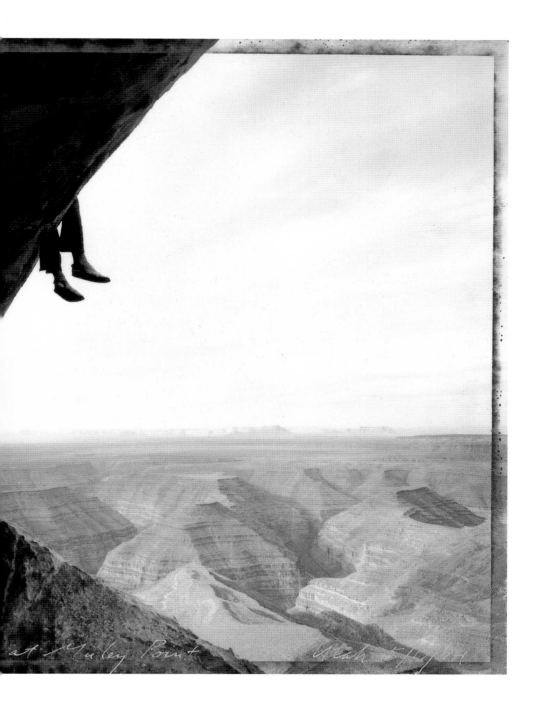

at Muley Point Utah

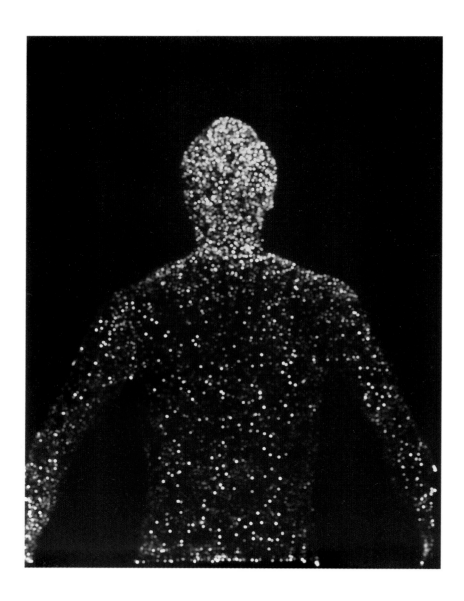

Christopher Bucklow | Guest (R. B.) 25,000 solar images, 1993

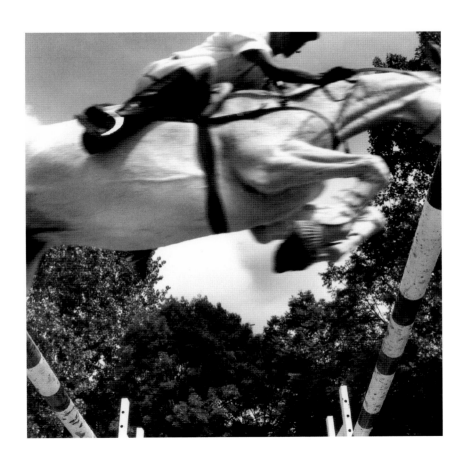

Agnès Bonnot | Concours International de Sauf d'Obstacle, Parc de la Courneuve (Seine St. Denis), 1994 **17**

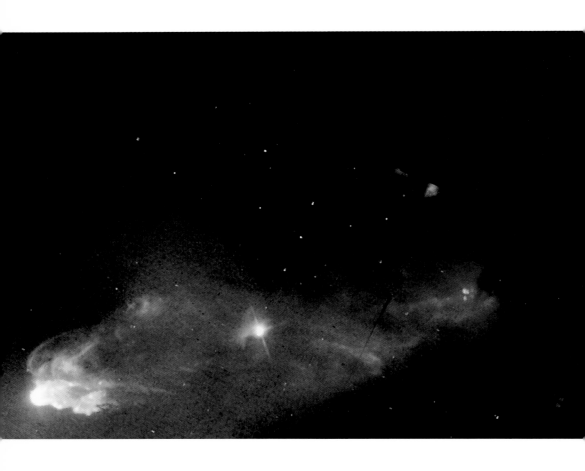

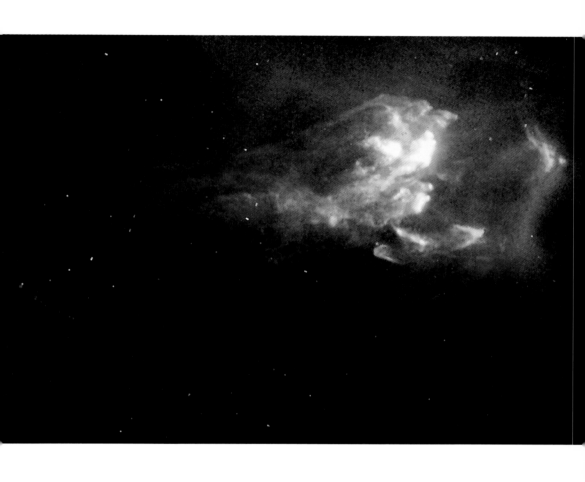

Jeff Hester (Arizona State University), and NASA | Jets from Young Stars, 1994

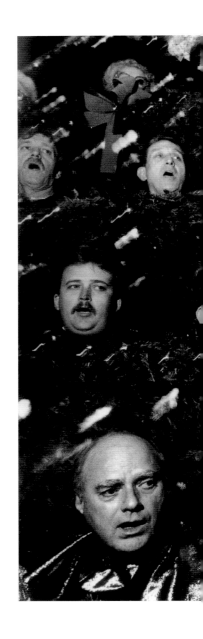

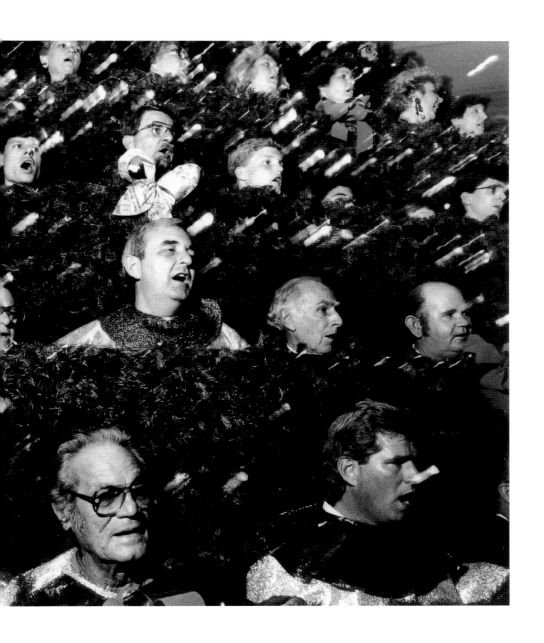

Gundula Schulze el Dowy | Erwin Visiting Tamerlan at the Hospital, Berlin, 1983 **23**

Michael Spano | Tree Trunk, Prospect Park, Brooklyn, New York, 1995

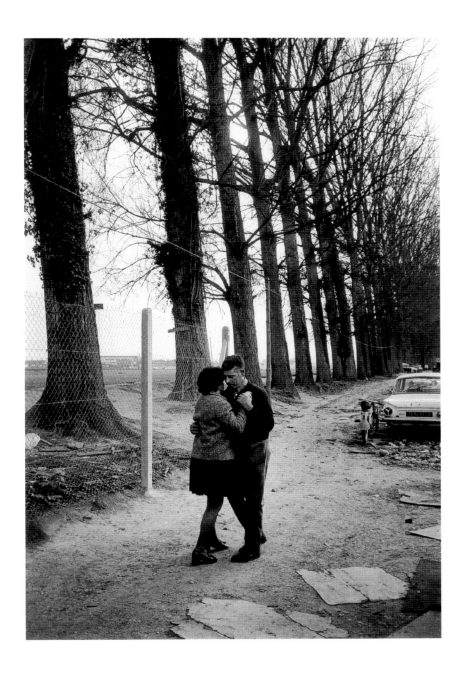

Gilles Peress | Untitled (Portuguese immigrants dancing on Sunday, Shantytown), 1973 **25**

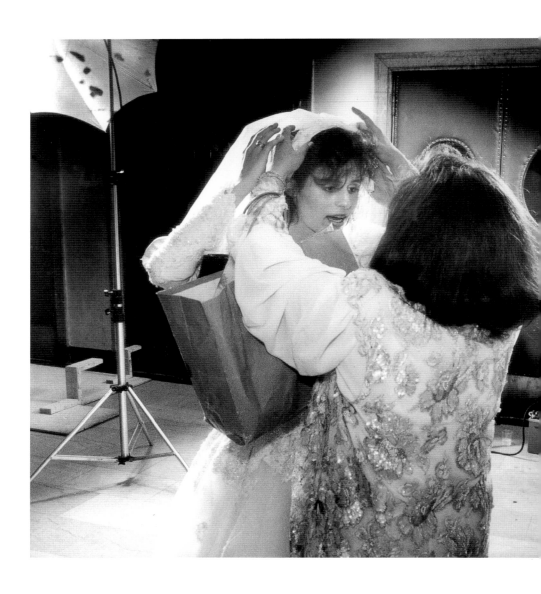

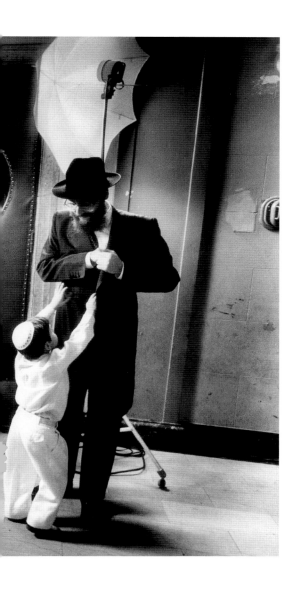

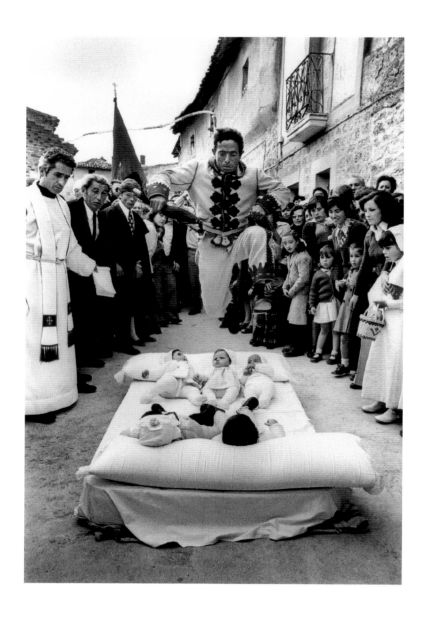

Cristina Garcia Rodero | El Colacho, Castrillo de Murcia, 1975

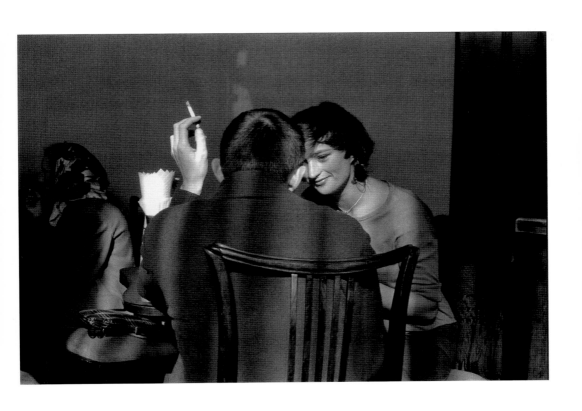

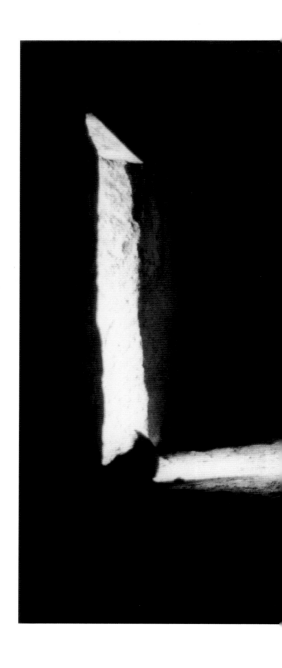

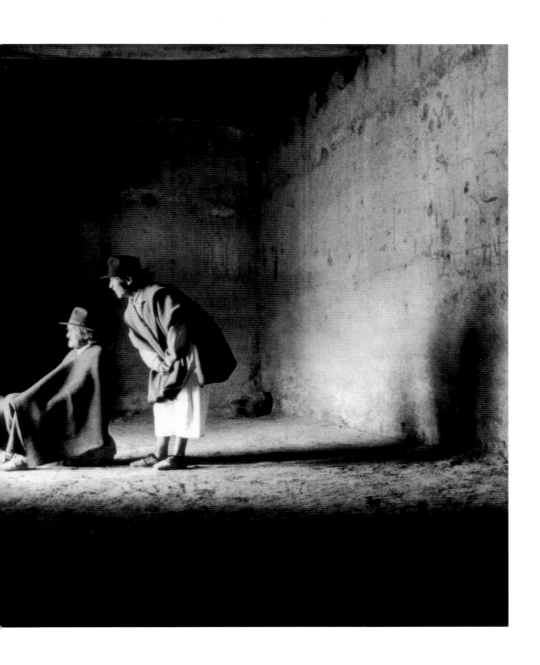

32 Larry Sultan | Grace, 1995

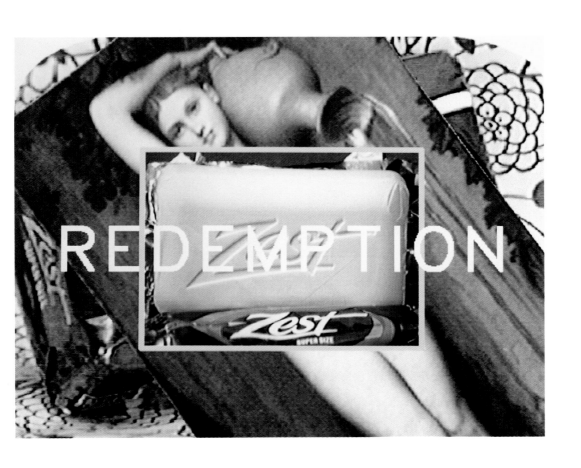

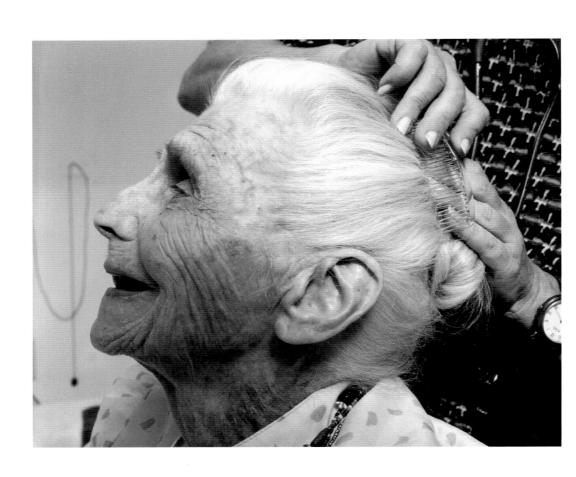

JoAnn Verburg | Untitled (Chaco Culture), 1993 **35**

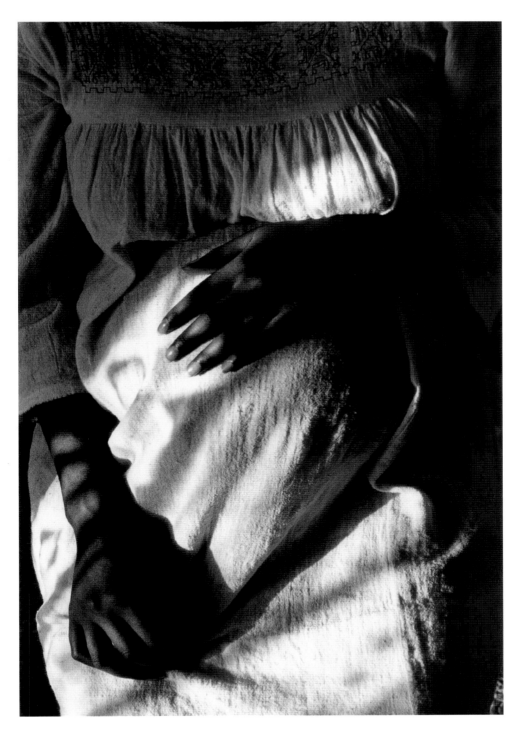

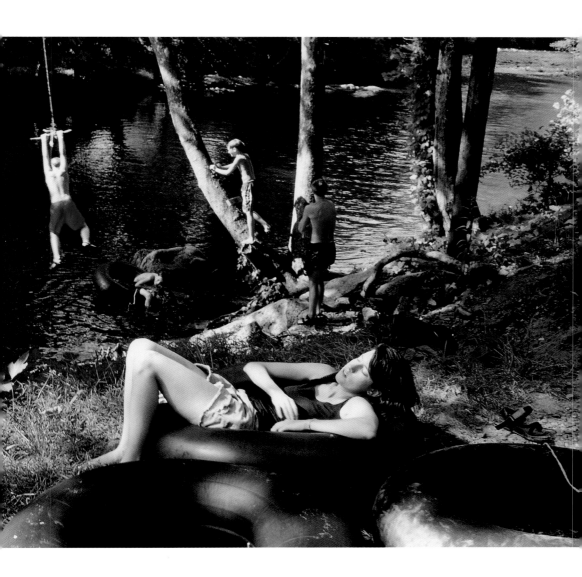

Reuben L. Cox | Cherokee, North Carolina, 1995 **39**

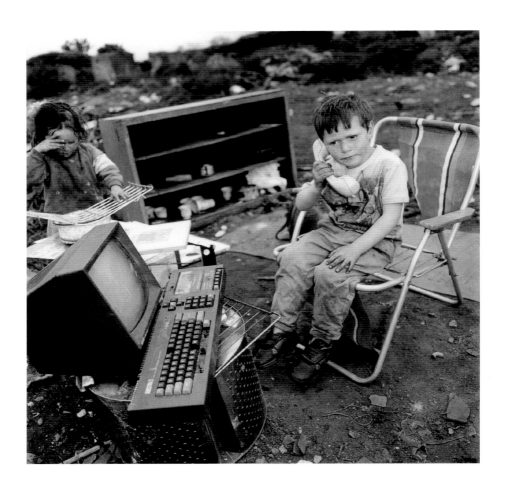

Mary Ellen Mark | Paddy Joyce, Traveller's Encampment, Finglas, Ireland, 1991

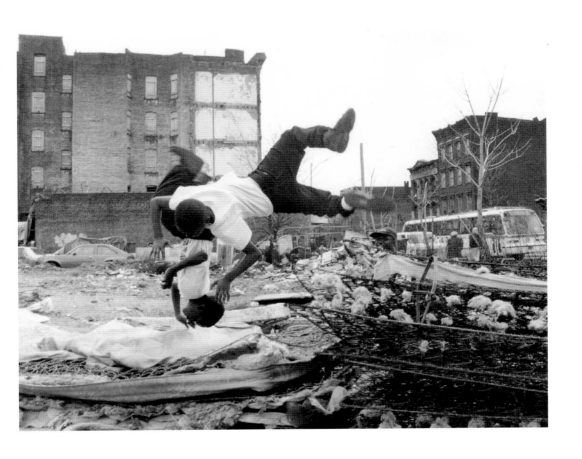

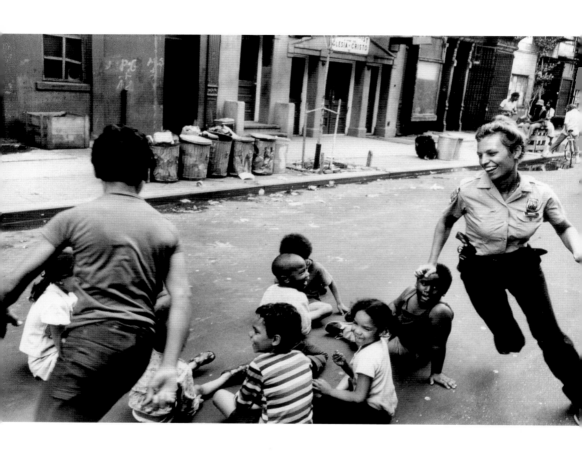

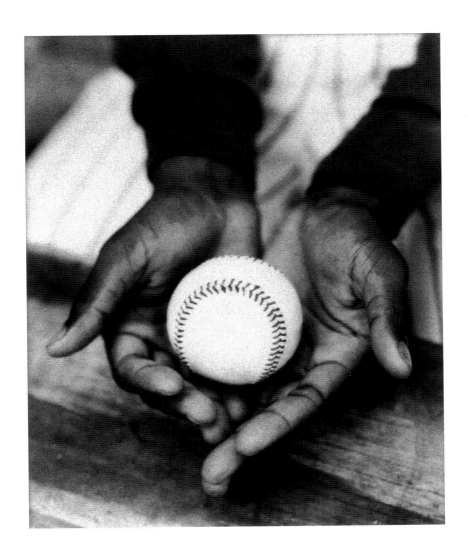

Andrea Modica | Oneonta, New York, 1992 **43**

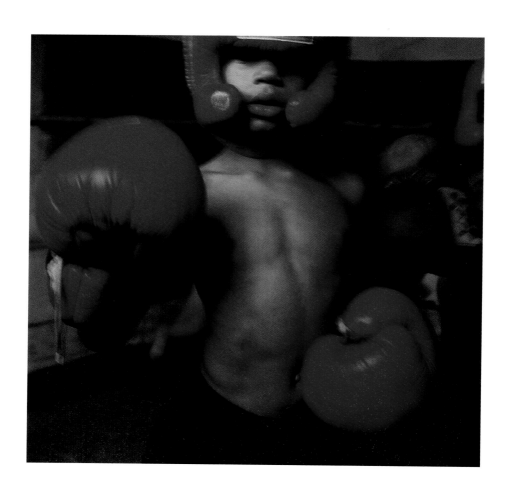

Miguel Rio Branco | Santa Rosa Kid, 1995

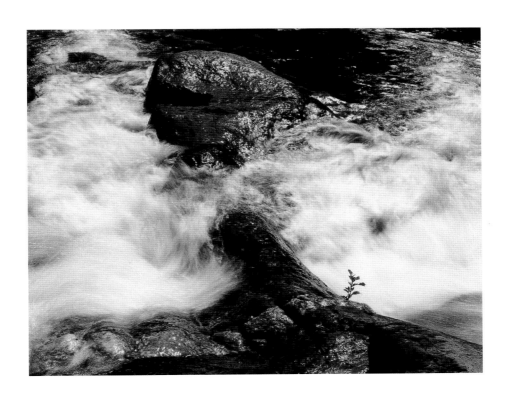

Koichiro Kurita | Cascade, Massachusetts, 1994 **45**

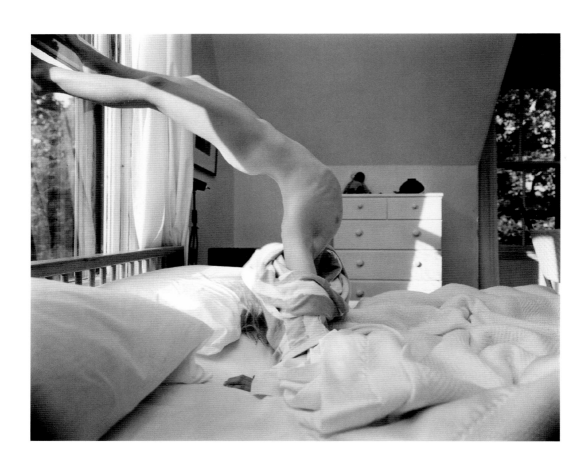

Nicholas Nixon | Clementine, Cambridge, 1992

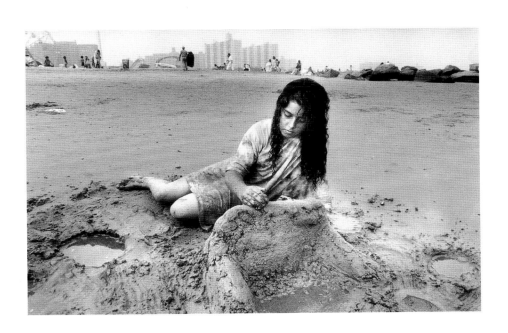

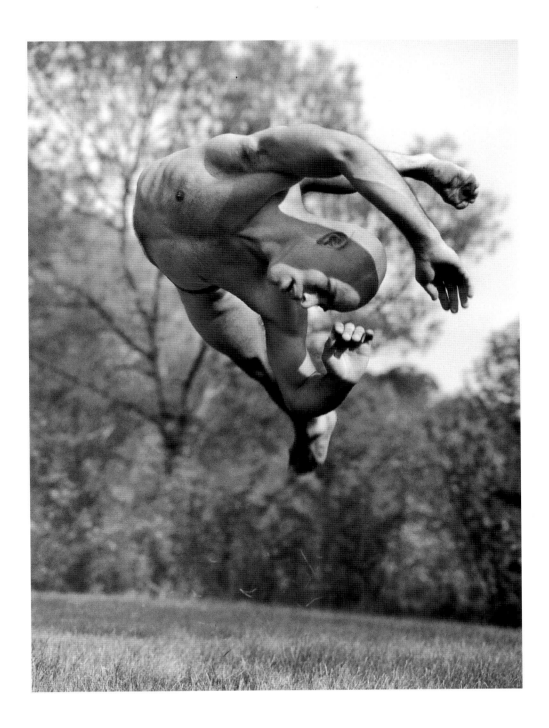

Philip Trager | Arthur Aviles, 1989 **49**

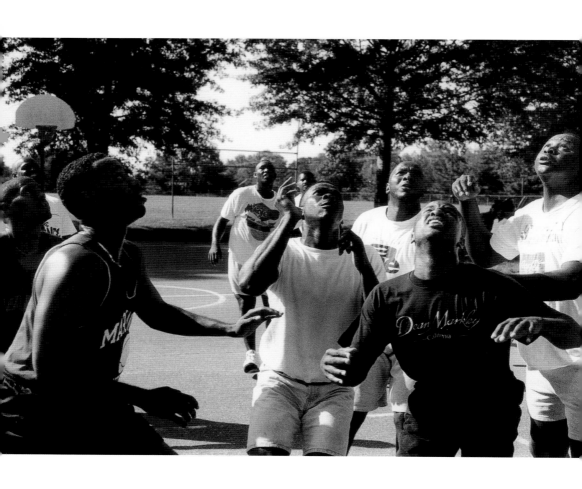

Brad Richman | Hillandale Recreation Center, Silver Spring, Maryland, August 1993

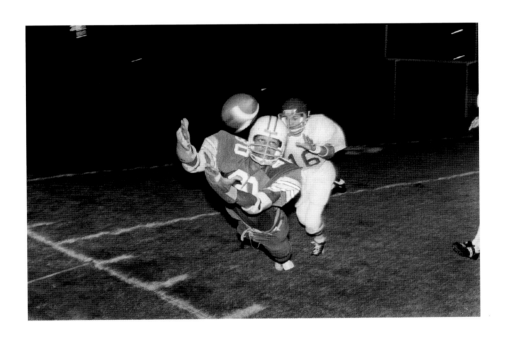

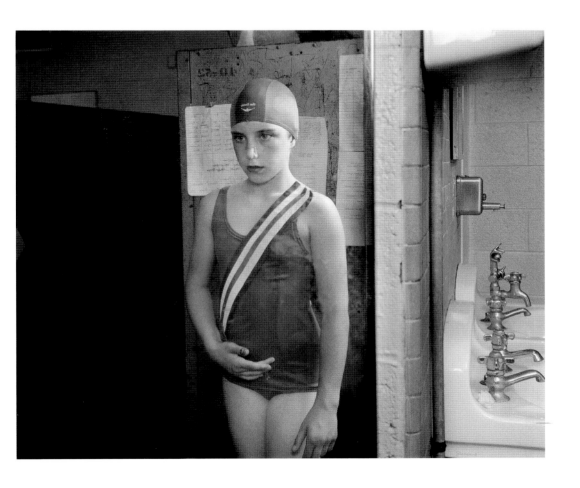

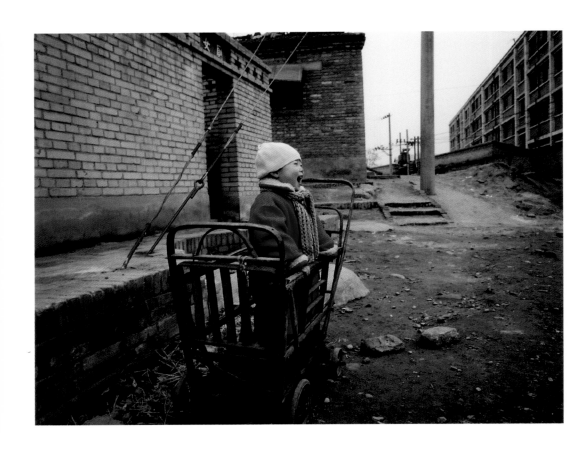

Reagan Louie | Beijing, 1987

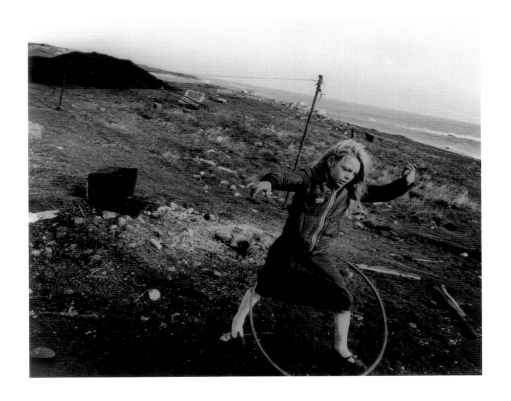

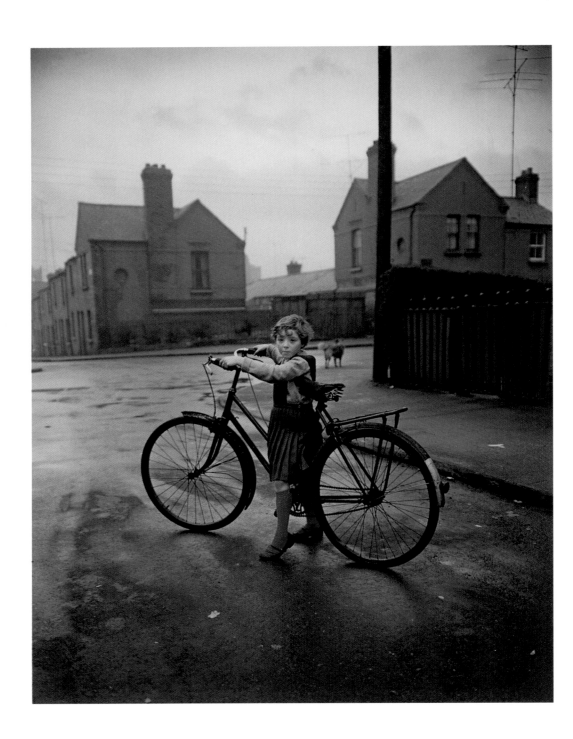

56 Evelyn Hofer | Girl in the Coombe, Dublin, 1966

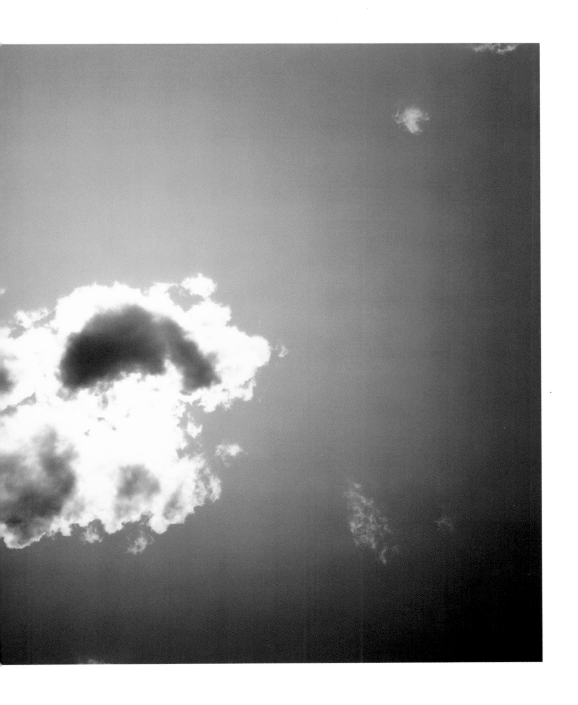

Richard Misrach | Cloud #150, 1992 **59**

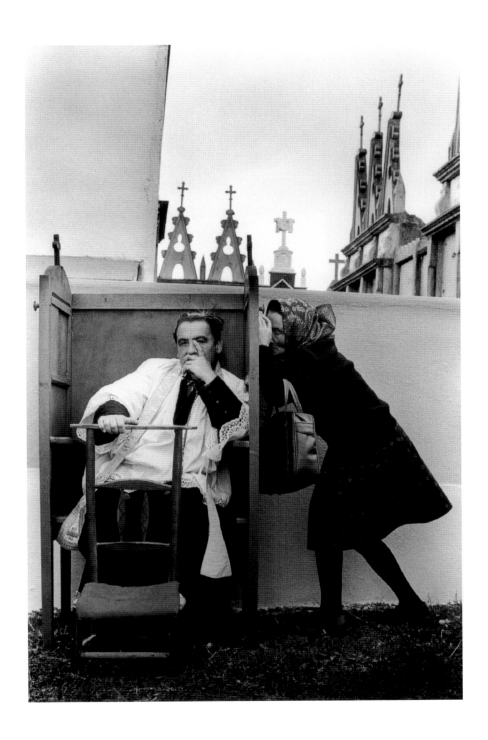

Cristina Garcia Rodero | La Confesion, Saavedra, 1980 **61**

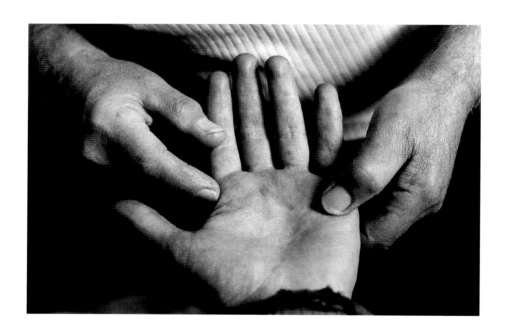

Graham MacIndoe | Fortune Teller, London, 1990

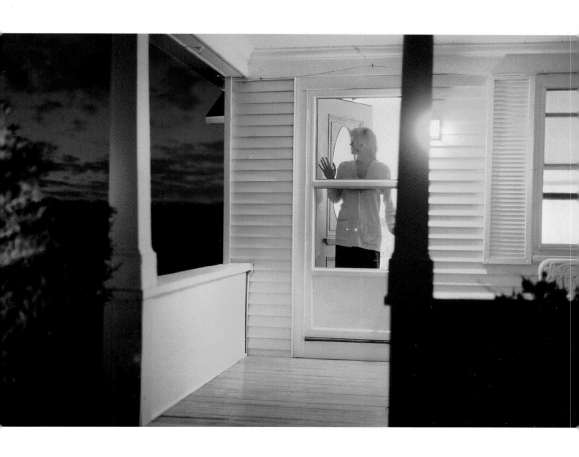

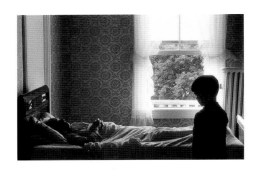

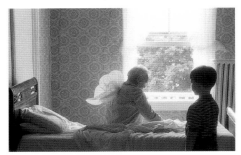

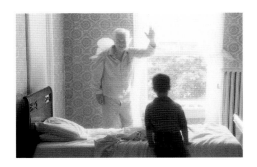

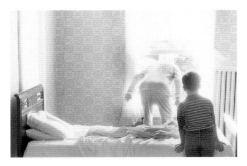

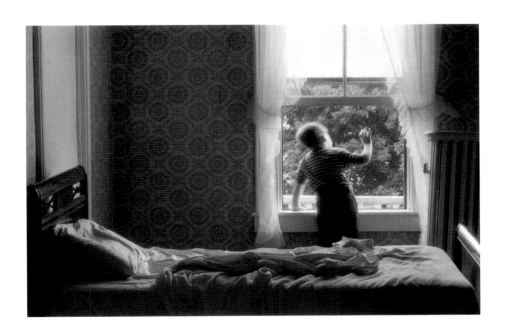

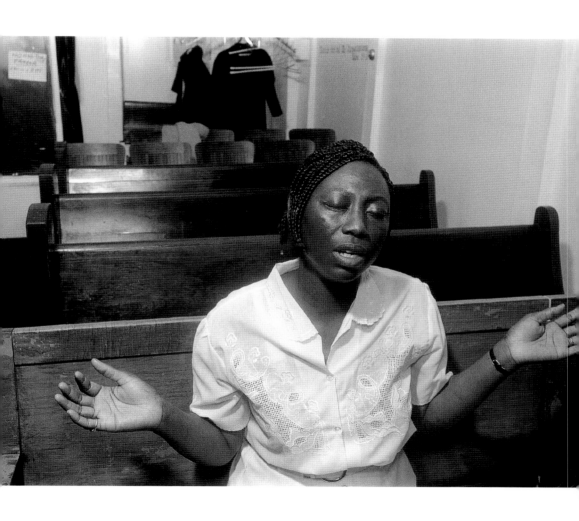

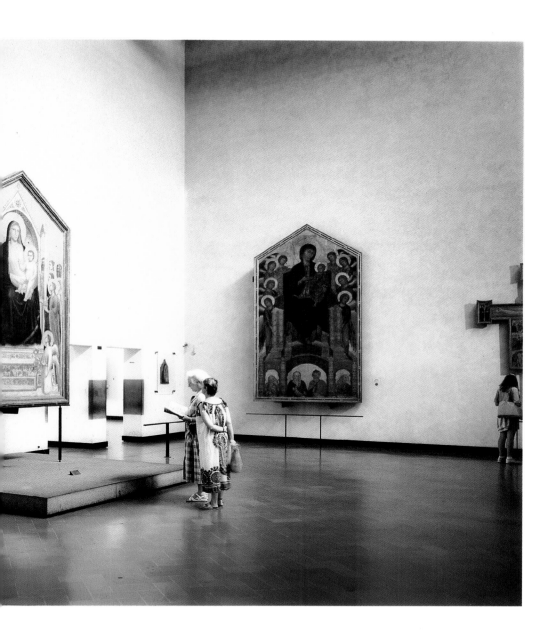

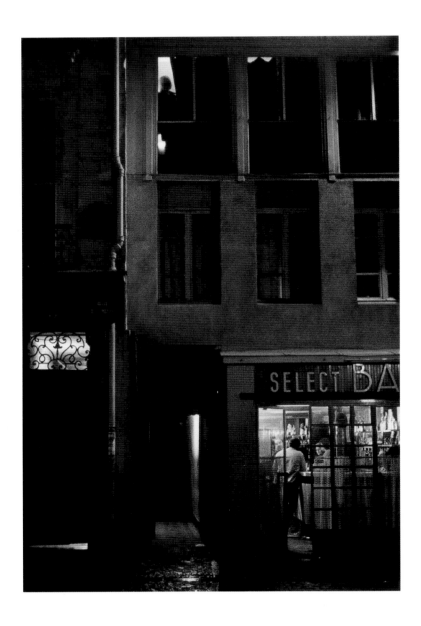

Jane Evelyn Atwood | Prostitute at Window, la rue des Lombardo, Paris, 1976

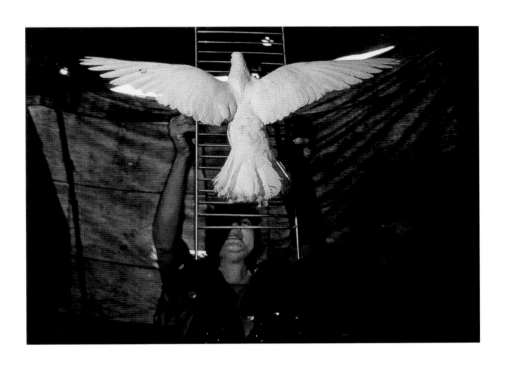

Ernesto Bazan | Circus Performer, Havana, Cuba, 1994 **71**

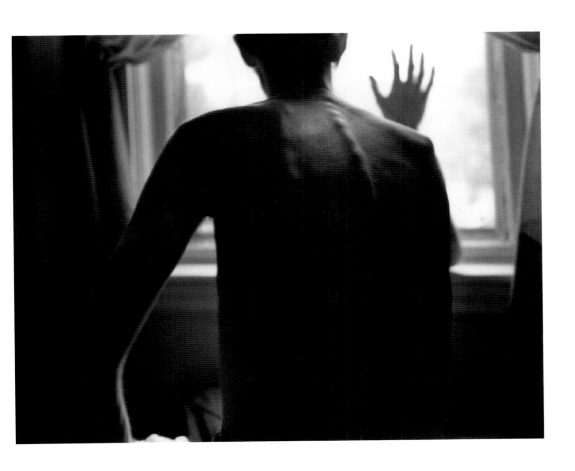

Nicholas Nixon | Tom Moran, G. Braintree, Massachusetts, September 1987 **73**

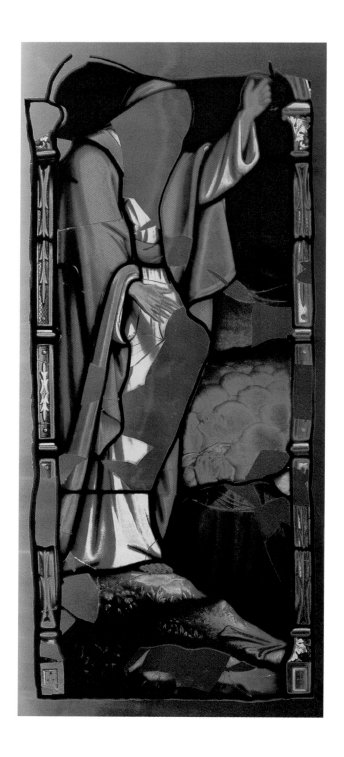

Adam Fuss | Untitled (faceless prophet preaching to the masses), 1995

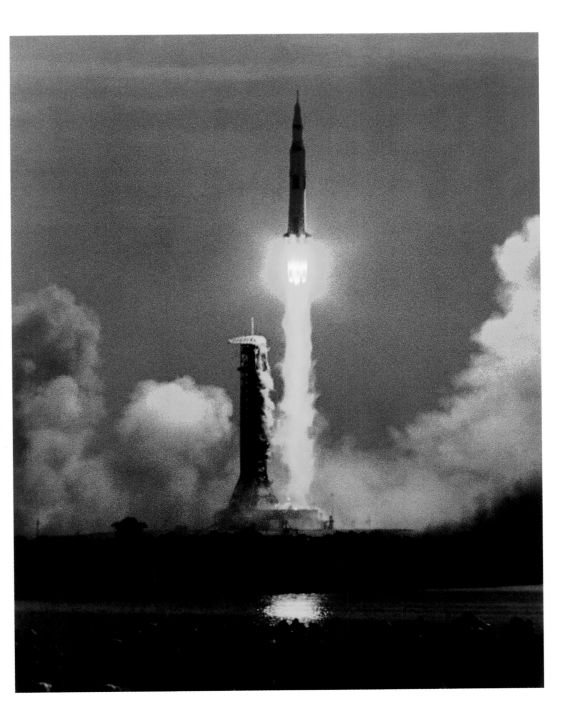

Hiro (Yasuhiro Wakabayashi)
APOLLO 11, 9:32 A.M., 7.16.69, Cape Canaveral, Florida: Maiden Voyage to the Moon **77**

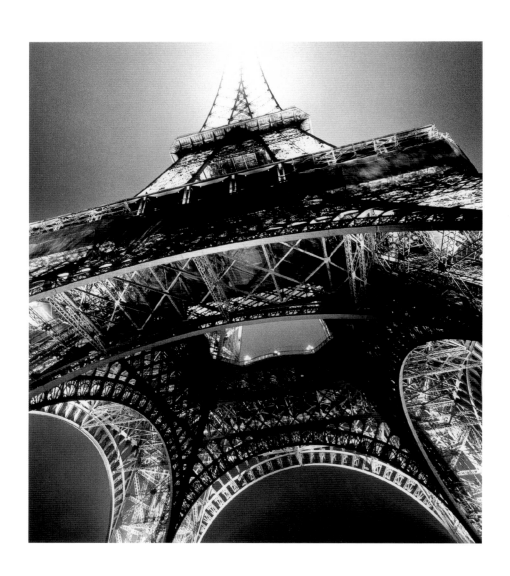

Michael Kenna | Eiffel Tower Study 3, 1987

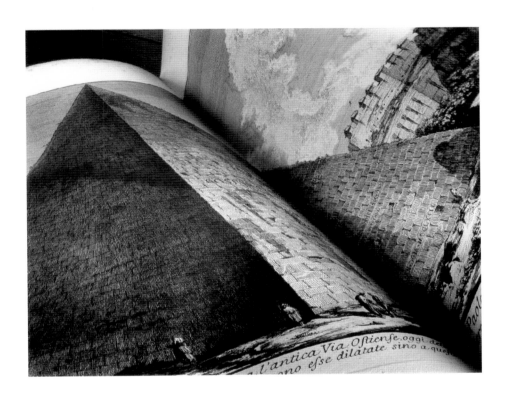

William Eggleston | Nashville, Tennessee, 1971

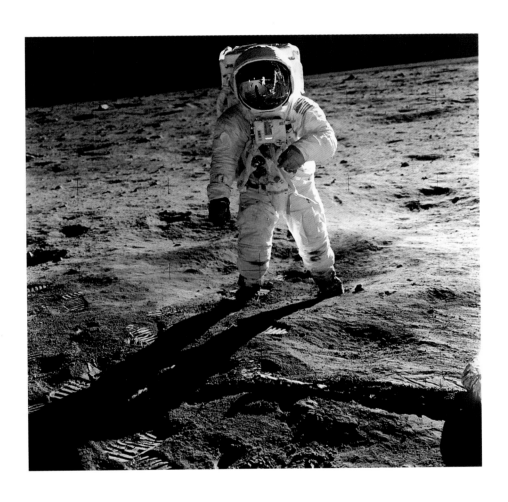

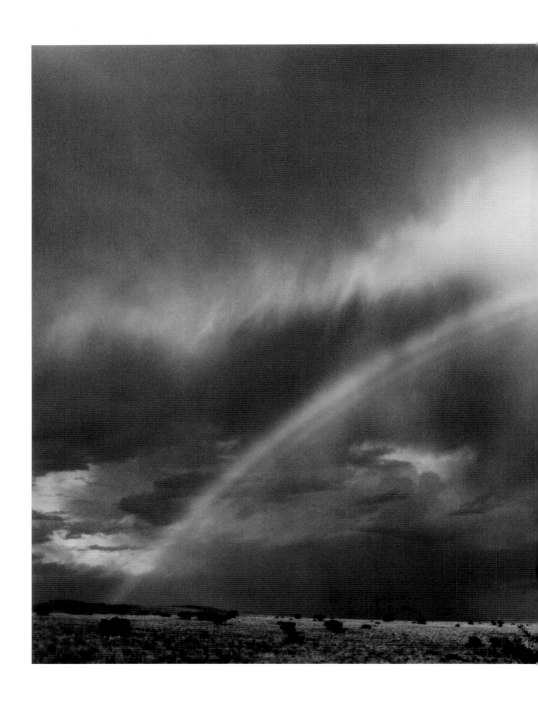

William Clift | Rainbow, Waldo, New Mexico, 1978

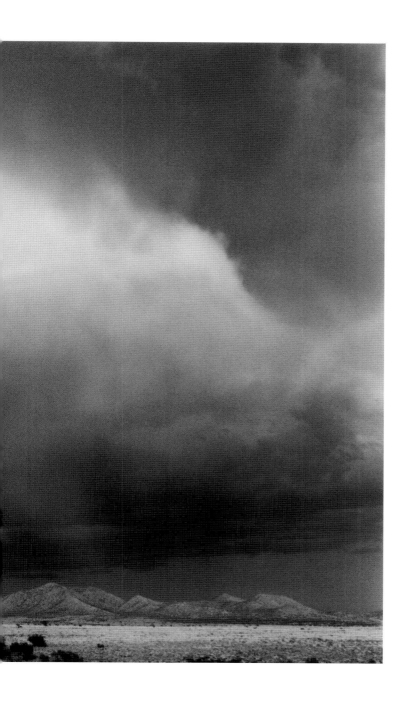

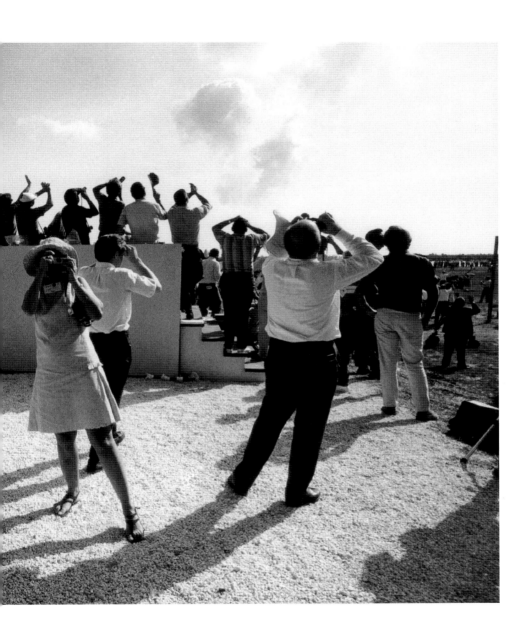

Garry Winogrand | Apollo 11 Moon Shot, Cape Kennedy, Florida, 1969 **91**

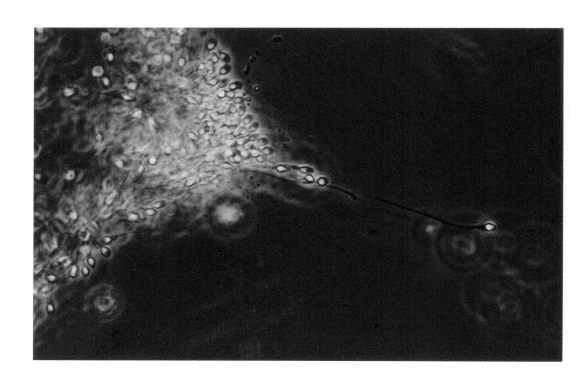

　　Lennart Nilsson | Untitled (sperm meeting egg), 1965

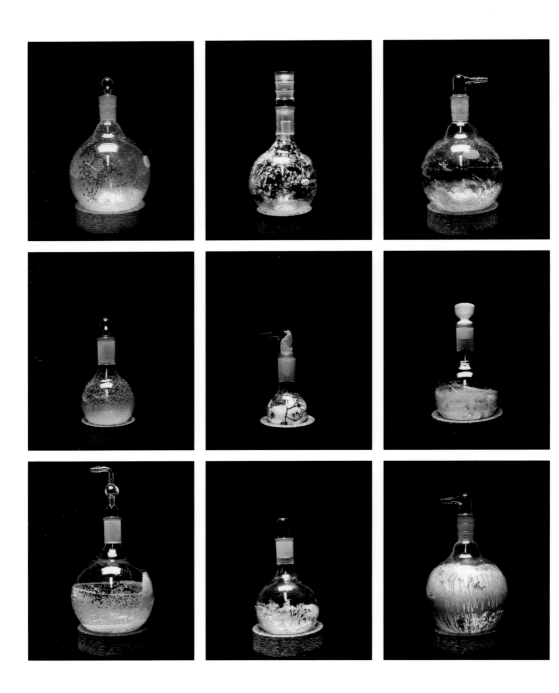

Catherine Wagner | Sequential Molecules Typology, 1995

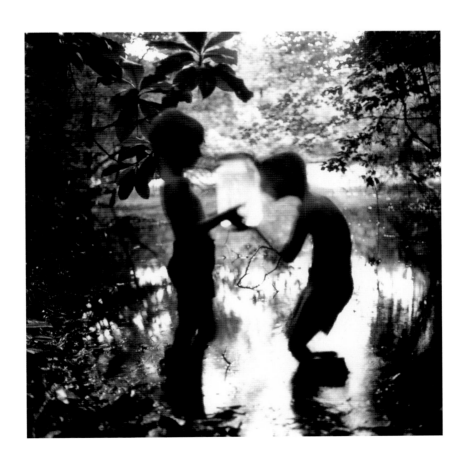

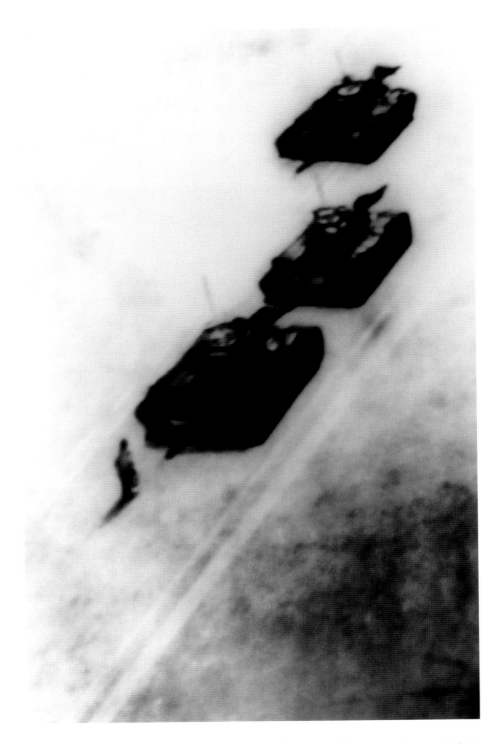

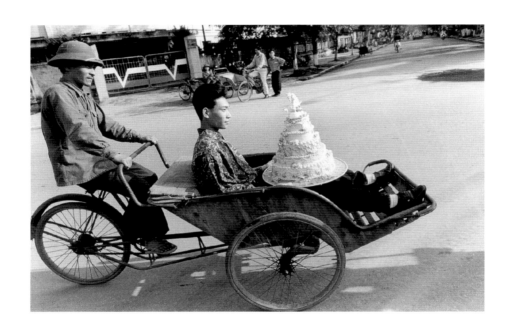

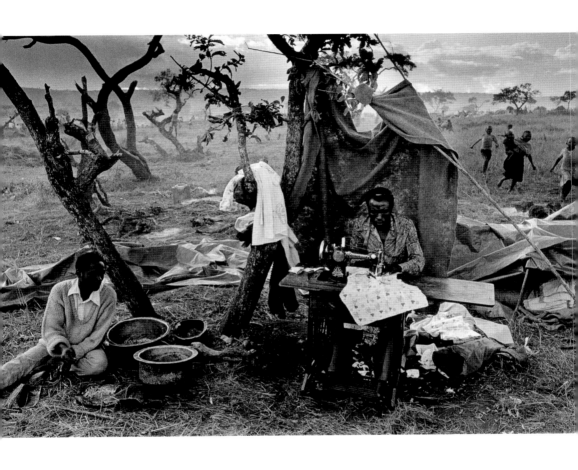

Witold Krassowski | A Tailor in Rwandan Refugee Camp Near Ngara, Tanzania, 1994

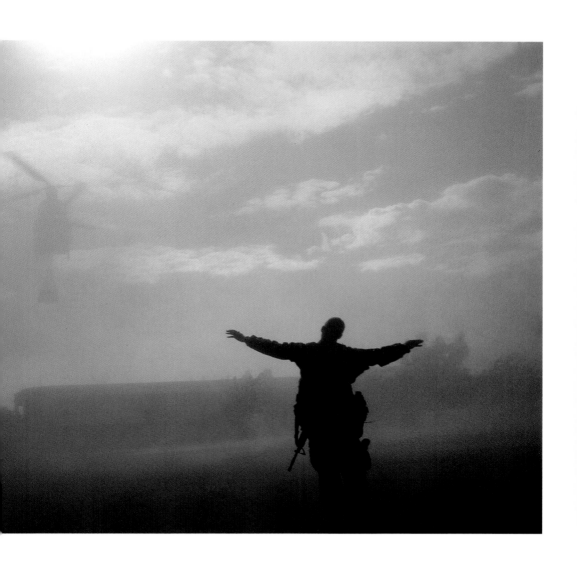

Alex Webb | Gonaives, Haiti, Arrival of the U.S. Military Helicopter, 1994 **101**

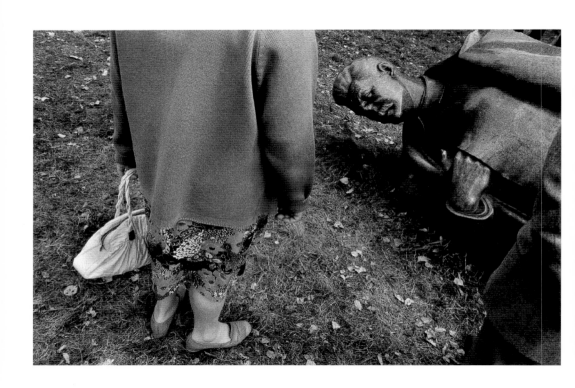

James Nubile ǀ Fallen Statue of Stalin, Moscow, September 1991

Mitch Epstein | Mai and Trinh Tuong, Hanoi, Vietnam, 1993 **103**

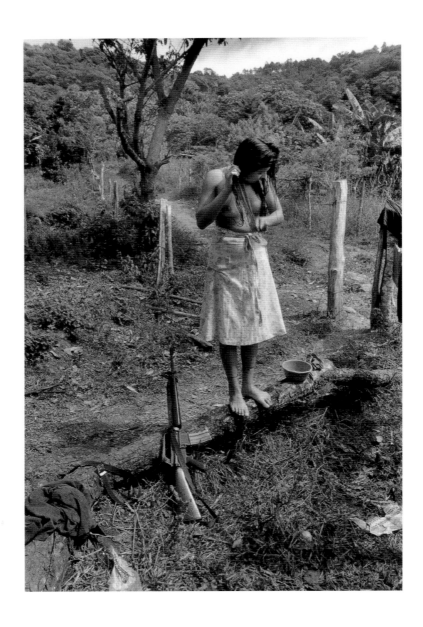

Larry Towell | Guerilla Woman Bathing, Morazàn, El Salvador, 1991

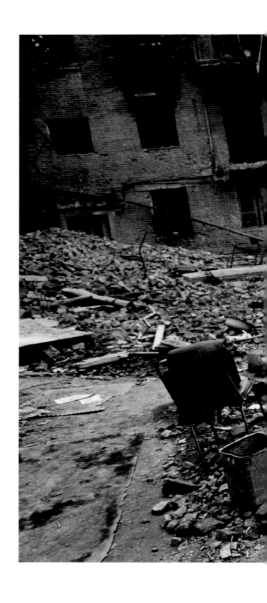

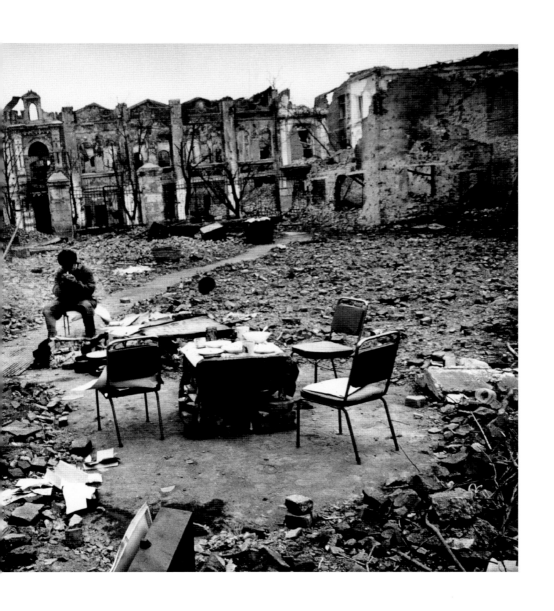

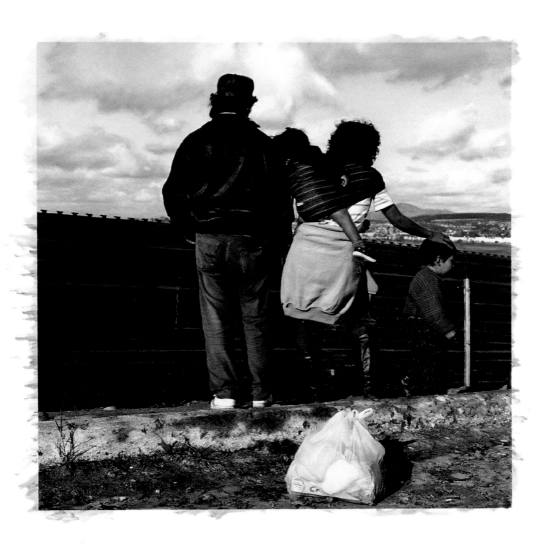

Ann Rhoney | Tijuana, Family Viewing California While Waiting to Run, 1992 **109**

Joel Sternfeld | Looking Across the Corrib River to Claddagh Quay, Galway, 1985

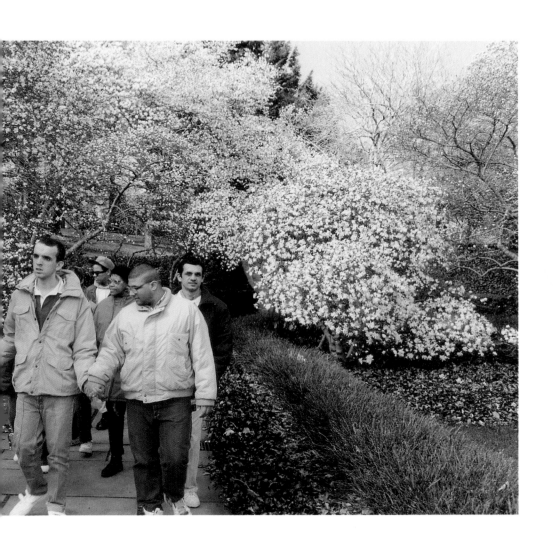

Max Kozloff | Brooklyn Botanical Garden, 1991 **113**

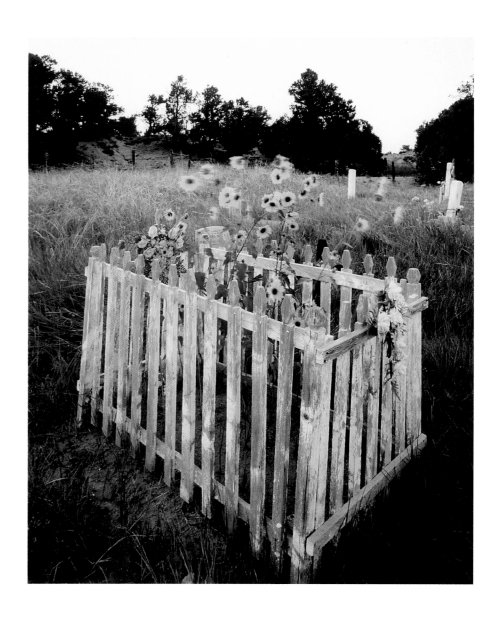

Alex Harris | Camposanto, El Valle, New Mexico, August 1986

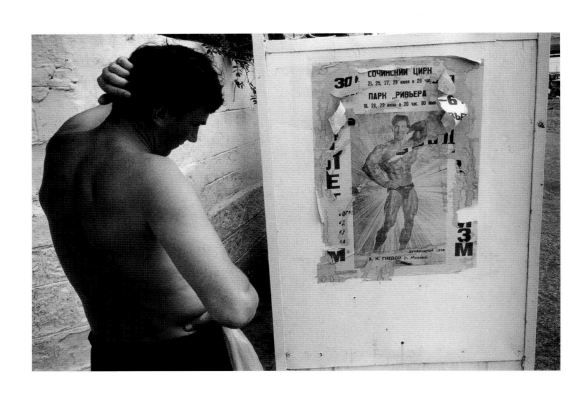

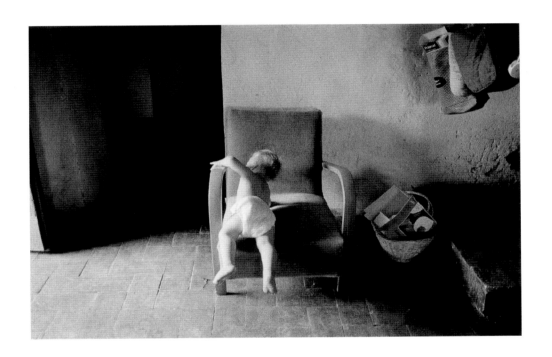

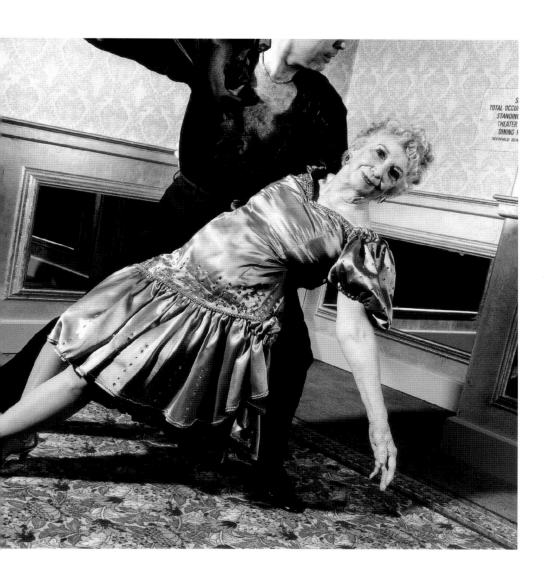

Mary Ellen Mark |
Margaret Nell Dances with Jerry Hill, Hilton Hotel Dance Showcase, Boca Raton, Florida, 1993 **119**

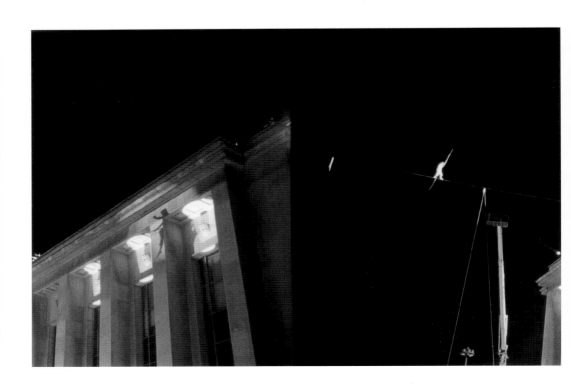

Gladys | "Le Funambule," Paris, 1984

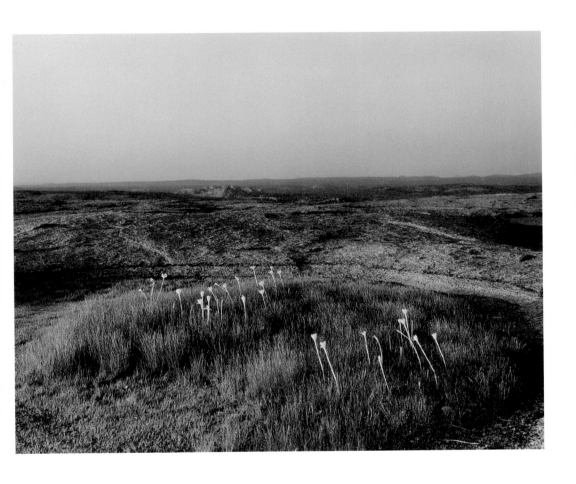

Evan Sklar | Enchanted Rock, near Fredericksburg, Texas, 1994 **121**

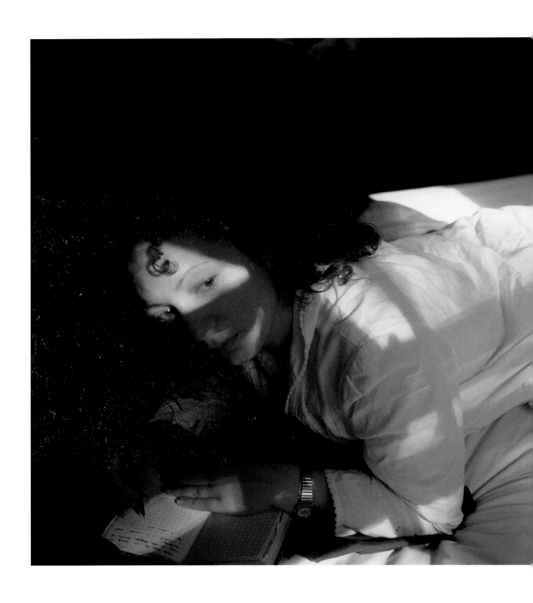

Nan Goldin | Self-Portrait Writing in Diary During De-Tox, Boston, 1989

124 Michelle Agins | Safe Haven, 1994

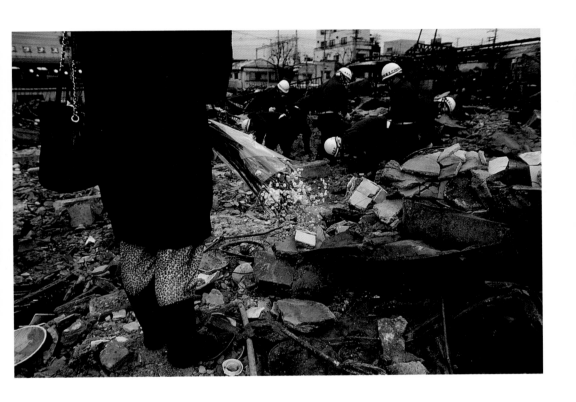

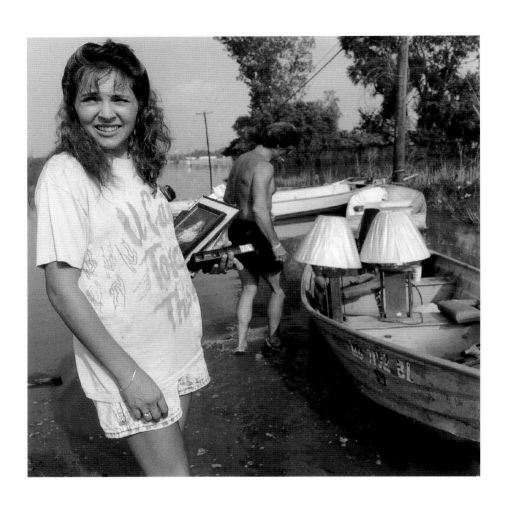

Rosalind Solomon | After the Flood, Hannibal, Missouri, 1993

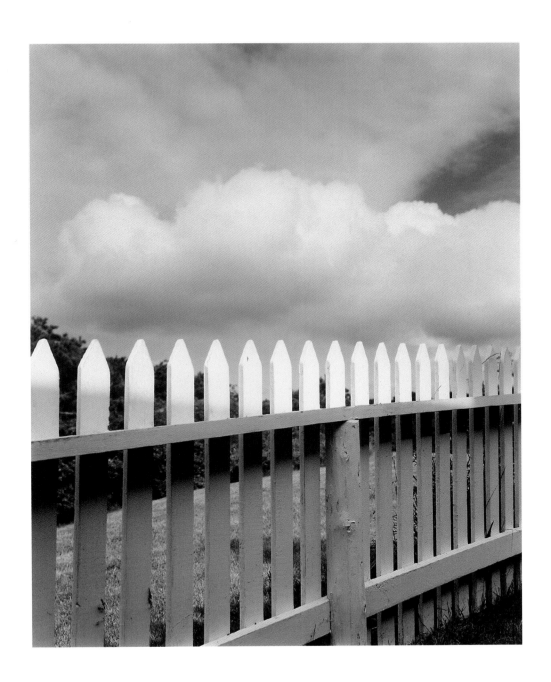

Joel Meyerowitz | The Fence, Truro, Cape Cod, 1976 **127**

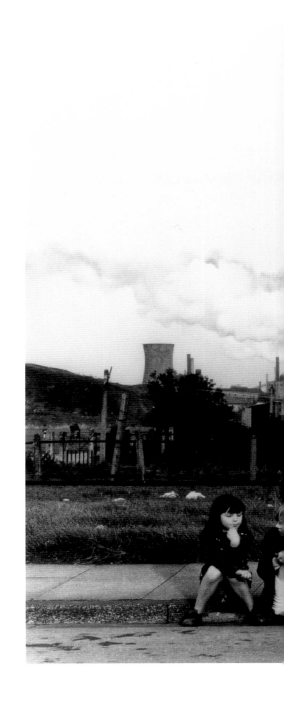

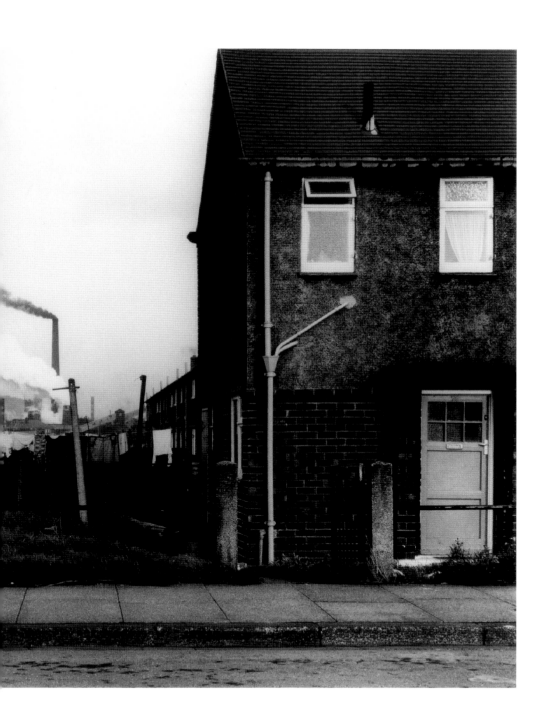

Chris Killip | Untitled, 1989 **129**

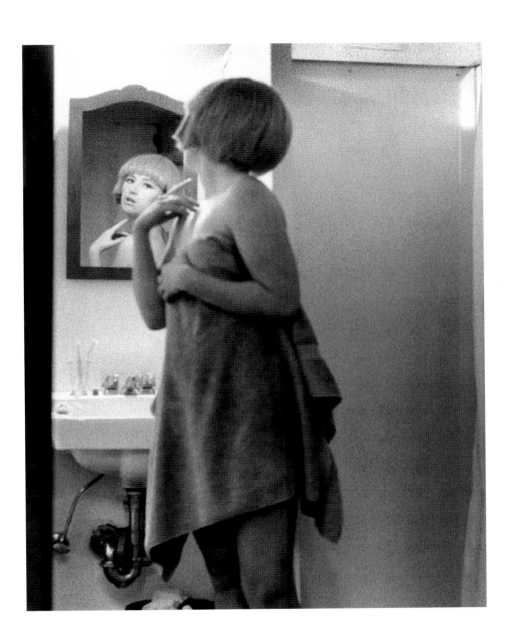

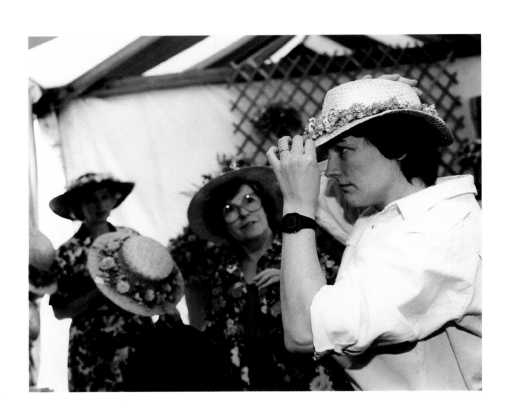

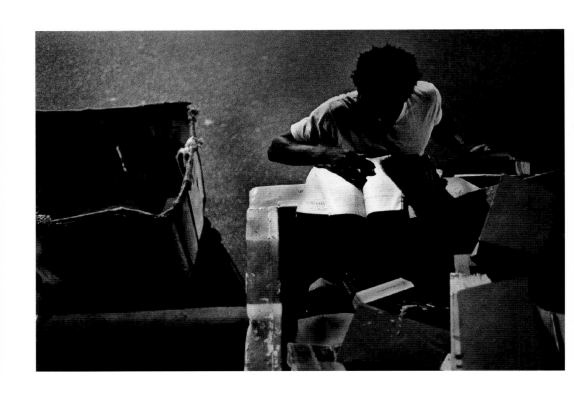

134 Edward Keating | Untitled (homeless man reading book amidst garbage), New York City, 1994

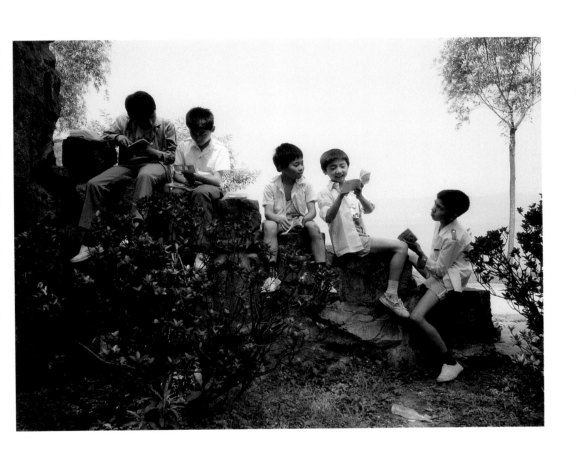

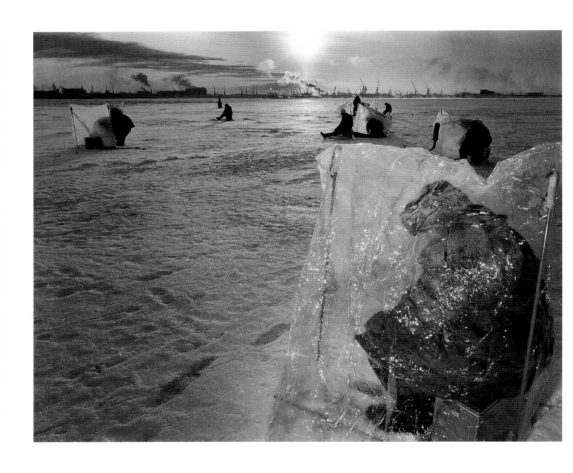

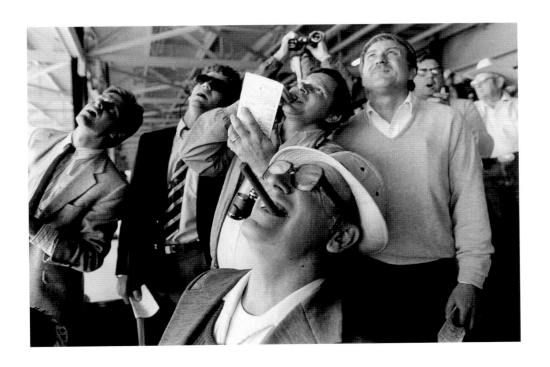

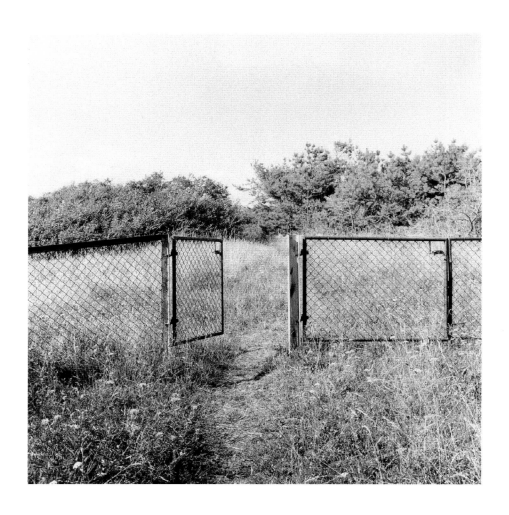

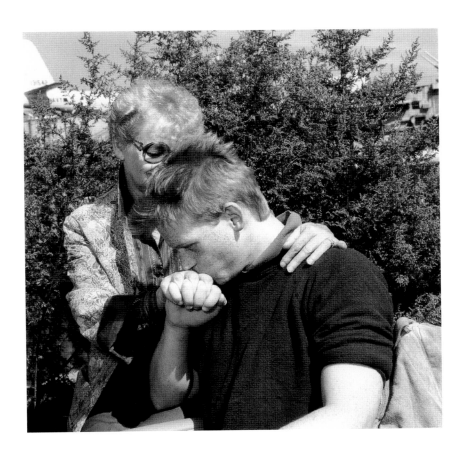

Rosalind Solomon | Nick and Nita Pippin, New York City (Portraits in the Time of AIDS), 1988 **139**

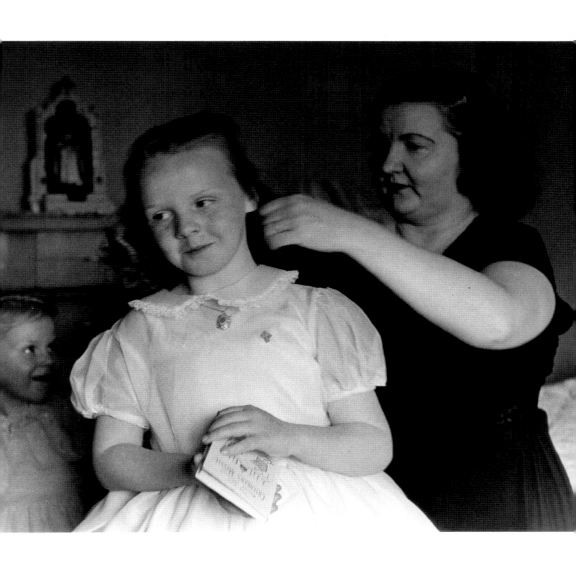

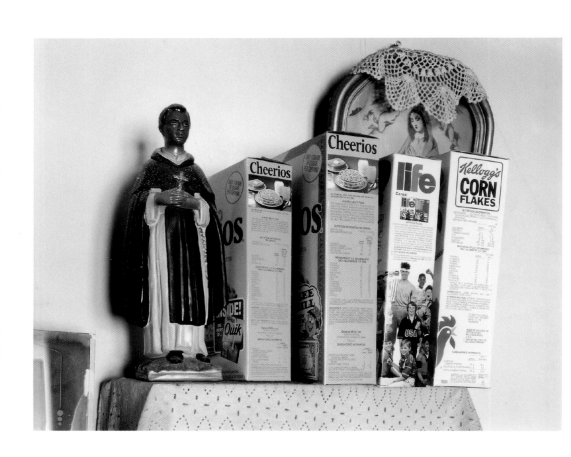

Hiroshi Sugimoto | Ionian Sea, Santa Cesarea, 1993 **145**

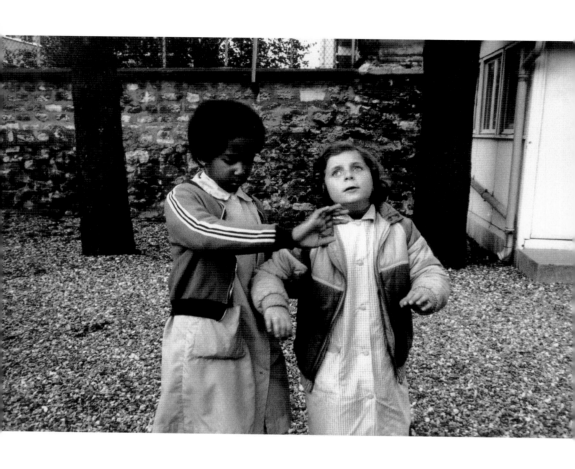

Jane Evelyn Atwood |
Blind Girls, L'Institut d'Education Sensorielle, Denfert Rochereau, Paris, France, 1980

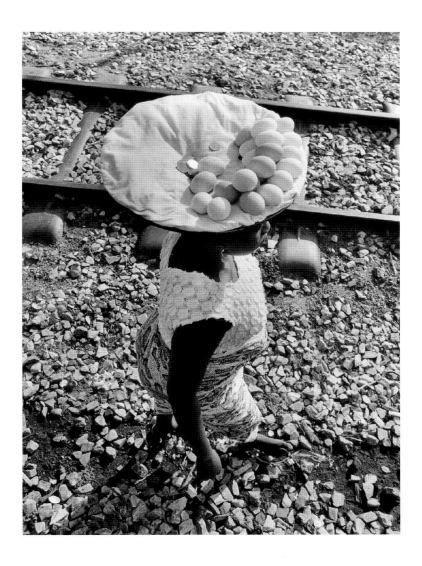

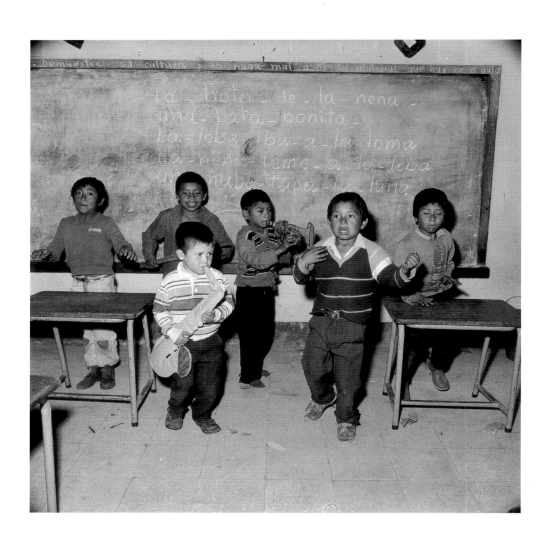

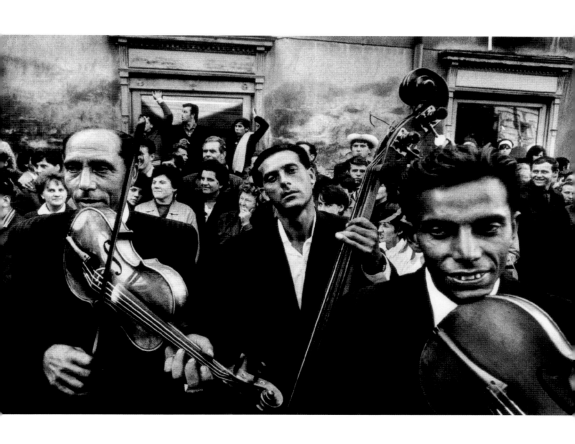

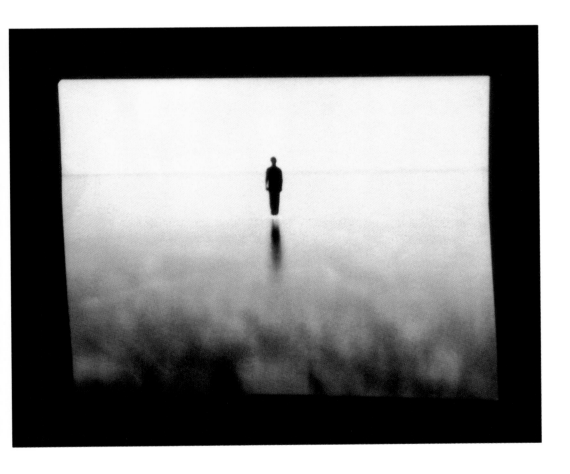

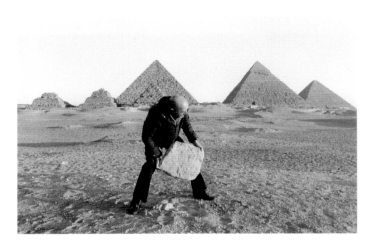

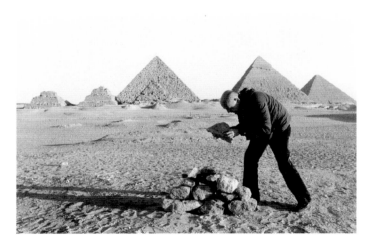

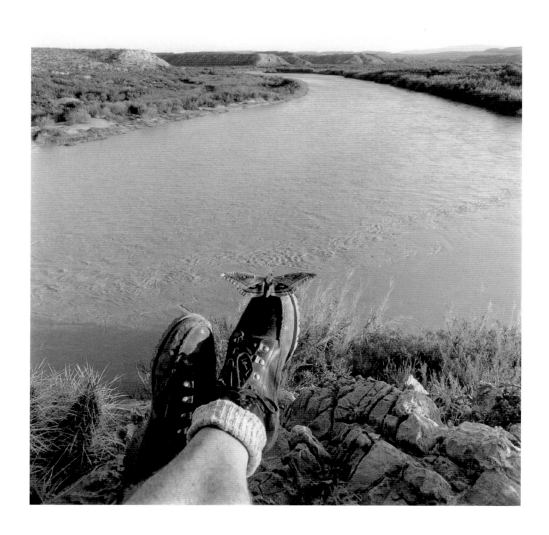

Credits

In addition to all other copyrights and reservations pertaining to works published in this catalogue and held by living artists, their estates, publications, and/or foundations, the following are noted:

© Robert Adams, Courtesy Fraenkel Gallery, San Francisco

© Michelle Agins/The New York Times

© Dag Alveng, Courtesy Deborah Bell, New York

© Agnès Bonnot/VU

© Edouard Boubat/Top-Rapho

© Christopher Bucklow, Courtesy Fraenkel Gallery, San Francisco

© Harry Callahan, Courtesy Jackson Fine Art, Atlanta

© William Clift 1978

© Carl De Keyzer/Magnum Photos

© Eggleston Artistic Trust 1971. All rights reserved. Used by permission.

© Leonard Freed/Magnum Photos

© Adam Fuss, Courtesy Robert Miller Gallery, New York

© Flor Garduño/Argento Immagine

© Gladys

© Ed Grazda 1994

© Richard Harbus

© Chester Higgins, Jr.

© Hiro 1969

© Edward Keating/The New York Times

© Mark Klett, Courtesy Fraenkel Gallery, San Francisco

© Josef Koudelka/Magnum Photos

© Witold Krassowski/Network

© Association des Amis de Jacques-Henri Lartigue;
 Hyperion Press/Monah L. Gettner

© Graham MacIndoe

© Joel Meyerowitz

© Richard Misrach, Courtesy Robert Mann Gallery, New York

© Andrea Modica, Courtesy Edwynn Houk Gallery, New York

© Abelardo Morrell, Courtesy Bonni Benrubi Gallery, New York

© Vik Muniz, Courtesy Wooster Gardens, New York

© NASA

© Mario Cravo Neto, Courtesy Witkin Gallery, New York

© Lennart Nilsson/Bonnierförlagen AB

© Christine Osinski

© Gilles Peress/Magnum Photos

© Sylvia Plachy

© Cristina Garcia Rodero, Courtesy Gallery of
 Contemporary Photography, Santa Monica

© Cindy Sherman, Courtesy Metro Pictures, New York

© Rosalind Solomon 1996

© Thomas Struth, Dusseldorf

© Hiroshi Sugimoto, Courtesy Fraenkel Gallery, San Francisco
 and Sonnabend Gallery, New York

© Anthony Suau

© Larry Sultan, Courtesy Janet Borden, Inc., New York

© Larry Towell/Magnum Photos

© JoAnn Verburg, Courtesy Robert Mann Gallery, New York

© The Estate of Garry Winogrand, courtesy Fraenkel Gallery,
 San Francisco

List of Photographers and Works

Robert **Adams,** *American, born 1937*
Dove Eggs, The Pawnee Grasslands,
Colorado, 1984
Gelatin silver print, 8 ¼ x 10 ¼ inches, page 7

Michelle **Agins,** *American*
Safe Haven, 1994
Gelatin silver print, 12 x 17 ¾ inches, page 124

Dag **Alveng,** *Norwegian, born 1953*
Open Gate, Hvasser, Norway, 1979
Gelatin silver print, 17 x 17 inches, page 138

Jane Evelyn **Atwood,** *American, born 1947*
Blind Girls, L'Institut d'Education
Sensorielle, Denfert Rochereau, Paris,
France, 1980
Gelatin silver print, 9 ⅝ x 14 ¼ inches, page 146

Prostitute at Window, la rue des
Lombardo, Paris, 1976
Gelatin silver print, 14 ¼ x 9 ¾ inches, page 70

Ernesto **Bazan,** *Cuban, born 1970s*
Circus Performer, Havana, Cuba, 1994
Gelatin silver print, 9 x 13 ½ inches, page 71

Ellen **Binder,** *American, born 1960*
Misha, 1992
Gelatin silver print, 12 ½ x 18 ⅜ inches, page 108

Agnès **Bonnot,** *French, born 1949*
Concours International de
Sauf d'Obstacle, Parc de la Courneuve
(Seine St. Denis), 1994
Gelatin silver print, 10 ½ x 10 ½ inches, page 17

Edouard **Boubat,** *French, born 1923*
Paris Maternité, 1971
Gelatin silver print, 15 ⅞ x 12 inches, page 37

Christopher **Bucklow,** *English, born 1957*
Guest (R. B.) 25,000 solar images, 1993
Unique Cibachrome photogram
(in-camera Cibachrome), 40 x 30 inches, page 16

Harry **Callahan,** *American, born 1912*
Atlanta, 1991–92
Set of four gelatin silver prints,
12 ⅞ x 13 inches each, page 81

Keith **Carter,** *American, born 1948*
Fireflies, 1992
Gelatin silver print, 14 ¾ x 14 ¾ inches,
page 95

Rio Grande, 1991
Gelatin silver print, 14 ¾ x 14 ¾ inches, page 154

William **Clift,** *American, born 1944*
Rainbow, Waldo, New Mexico, 1978
Gelatin silver print, 15 ⅞ x 22 ⅞ inches, page 84

Reuben L. **Cox,** *American, born 1972*
Cherokee, North Carolina, 1995
Chromogenic color print, 12 ½ x 19 inches, page 39

Carl **De Keyzer,** *Belgian, born 1958*
Leningrad, USSR, 1988
Gelatin silver print, 16 x 19 ½ inches, page 136

Savannah, Georgia, 1990
Gelatin silver print, 16 x 19 ½ inches, page 21

Philip-Lorca **diCorcia,** *American, born 1951*
Noemi, 1987
Chromogenic color print, 15 ¾ x 23 inches, page 63

William **Eggleston,** *American, born 1939*
Nashville, Tennessee, 1971
Dye transfer, 12 ½ x 18 inches, page 82

Mitch **Epstein,** *American, born 1952*
Mai and Trinh Tuong, Hanoi,
Vietnam, 1993
Fuji chromogenic color print, 22 x 15 inches, page 103

Larry **Fink,** *American, born 1941*
First Communion, 1961
Gelatin silver print, 14 ½ x 18 ¾ inches, page 141

Leonard **Freed,** *American, born 1929*
A Policewoman Playing Games
with Community Children, 1978
Gelatin silver print, 8 ⅛ x 12 inches, page 42

Lee **Friedlander,** *American, born 1934*
Cray, 1986
Gelatin silver print, 15 x 22 ½ inches, page 89

Adam **Fuss,** *English, born 1961*
Untitled (faceless prophet preaching
to the masses), 1995
Cibachrome photogram, 45 x 20 inches, page 74

Flor **Garduño,** *Mexican, born 1957*
Taito Marcos, Ecuador, 1988
Platinum print, 7 x 9 ¾ inches, page 31

Gladys, *French*
"Le Funambule," Paris, 1984
Gelatin silver print, 5 ¼ x 8 ⅜ inches, page 120

Nan **Goldin,** *American, born 1953*
Self-Portrait Writing in Diary
During De-Tox, Boston, 1989
Cibachrome print, 16 x 23 ½ inches, page 122

Edward **Grazda,** *American, born 1947*
Haiphong, Vietnam, 1994
Gelatin silver print, 12 ½ x 18 ¾ inches, page 98

Richard **Harbus,** *American, born 1958*
Bronx, New York, 1994
Gelatin silver print, 6 ¾ x 9 ⅞ inches, page 41

Alex **Harris,** *American, born 1949*
St. Martin de Porres and the Virgin Mary,
Rosenda Medina's House, Penasco,
New Mexico, December 1986
Chromogenic color print, 18 x 22 ³/₄ inches, page 142

Camposanto, El Valle, New Mexico,
August 1986
Chromogenic color print, 23 x 18 ¹/₄ inches, page 114

Jeff **Hester** (Arizona State University),
and NASA
Jets from Young Stars, 1994
Chromogenic color print, 8 ¹/₄ x 24 inches, page 19

Chester **Higgins, Jr.,** *American, born 1946*
An Egg Vendor, Ghana, 1974
Gelatin silver print, 19 x 13 inches, page 147

Hiro (Yasuhiro Wakabayashi), *Japanese,
born Shanghai 1930*
APOLLO 11, 9:32 A.M., 7. 16. 69,
Cape Canaveral, Florida: Maiden Voyage
to the Moon
Dye transfer, 38 ¹/₈ x 26 ⁷/₈ inches, page 77

Evelyn **Hofer,** *American, born Germany 1937*
Girl in the Coombe, Dublin, 1966
Dye transfer, 13 ³/₈ x 10 ³/₈ inches, page 56

Henry **Horenstein,** *American, born 1947*
Turning for Home, Keeneland, 1985
Gelatin silver print, 12 x 18 inches, page 137

Frank **Horvat,** *French, born Italy 1928*
Warsaw, 1963
Gelatin silver print, 9 ¹/₂ x 14 inches, page 29

James H. **Karales,** *American, born 1930*
Marchers, Selma to Montgomery,
Alabama, 1965
Gelatin silver print, 13 ¹/₄ x 19 ³/₄ inches, page 11

Karen **Kasmauski,** *American, born 1953*
Kobe Earthquake, 1995
Chromogenic color print, 10 ¹/₄ x 13 ¹/₄ inches,
page 125

Edward **Keating,** *American, born 1956*
Untitled (homeless man reading book
amidst garbage), New York City, 1994
Gelatin silver print, 8 ³/₄ x 12 ⁷/₈ inches, page 134

Michael **Kenna,** *British, born 1953*
Eiffel Tower Study 3, 1987
Gelatin silver print, 17 ¹/₂ x 15 ¹/₄ inches, page 78

Chris **Killip,** *British, born 1946*
Untitled, 1989
Gelatin silver print, 16 x 20 ¹/₂ inches, page 129

Girl with Hoop, 1987
Gelatin silver print, 16 ¹/₄ x 20 inches, page 55

Mark **Klett,** *American, born 1949*
Contemplating the View at Muley Point,
Utah, 1994
Gelatin silver print, 14 ³/₄ x 19 inches, page 15

Josef **Koudelka,** *French, born Czechoslavakia 1938*
Straznice, 1965
Gelatin silver print, 14 ¹/₂ x 22 inches, page 149

Max **Kozloff,** *American, born 1933*
Brooklyn Botanical Garden, 1991
Chromogenic color print, 13 ¹/₈ x 19 ¹/₂ inches,
page 113

Witold **Krassowski,** *Polish, born 1956*
A Tailor in Rwandan Refugee Camp Near
Ngara, Tanzania, 1994
Gelatin silver print, 13 x 19 ¹/₂ inches, page 99

Koichiro **Kurita,** *Japanese, born Manchuria 1943*
Cascade, Massachusetts, 1994
Gelatin silver print, 16 ¹/₂ x 20 ¹/₂ inches, page 45

Jacques-Henri **Lartigue,** *French, 1894–1986*
The ZYX 24 takes off. Piroux, Zissou,
George, Louis, Dédé and Robert try to take
off, too. Rouzat, 1910
Gelatin silver print, 15 ¹/₂ x 21 ¹/₄ inches, page 4

Reagan **Louie,** *American, born 1951*
Hangzhou, 1987
Chromogenic color print, 19 x 23 inches, page 135

Beijing, 1987
Chromogenic color print, 19 x 23 inches, page 54

Shanghai, 1989
Chromogenic color print, 19 x 23 inches, page 105

Graham **MacIndoe,** *British, born 1963*
Fortune Teller, London, 1990
Gelatin silver print, 10 x 15 inches, page 62

MANUAL (Suzanne **Bloom** and Edward **Hill**)
Americans, born 1943 and 1935
Redemption, 1988
Ektacolor print (computer-generated image),
17 x 22 inches, page 33

Martino **Marangoni,** *American, born 1950*
Matteo Climbing Chair, 1983
Gelatin silver print, 10 ¹/₈ x 14 ³/₄ inches, page 117

Mary Ellen **Mark,** *American, born 1940*
Margaret Nell Dances with Jerry Hill,
Hilton Hotel Dance Showcase, Boca Raton,
Florida, 1993
Gelatin silver print, 14 ³/₄ x 19 inches, page 119

Paddy Joyce, Traveller's Encampment,
Finglas, Ireland, 1991
Gelatin silver print, 15 x 15 inches, page 40

Joel **Meyerowitz,** *American, born 1938*
The Fence, Truro, Cape Cod, 1976
Chromogenic color print, 23 ¹/₂ x 18 ¹/₂ inches,
page 127

The Look of Hope Reynolds Price

The Oxford English Dictionary, **hope:**
Expectation of something desired; desire combined with
expectation.

The American Heritage Dictionary, **hope:**
The desire and search for a future good, difficult but
not impossible to attain....

Paul of Tarsus, *The First Letter to the Corinthians:*
Now trust, hope, love remain; but the greatest of these is love.

Ludwig van Beethoven was overtaken, before the age of thirty, by a
deafness that would only increase with time and threaten both his sanity
and his very existence—all his human contacts, his art and his liveli-
hood—yet he barely slowed the regular progress of his daily work.
Indeed, in deepening silence, his music in its many forms steadily grew in
power and depth; and by the time he began final revisions on his single
opera *Fidelio,* he was in his mid-forties, well past the center point of his
life and howlingly lonely (he would die at fifty-six, never married and
childless).

With its story of the loyal wife of a political prisoner who disguises
herself as a young prison guard in the hope of discovering and saving her
husband, the opera drew from Beethoven long stretches of the most
uncannily poignant music of his middle years; and no moment in *Fidelio*
is more arresting—more designed to flow, in Beethoven's words, "from
the heart to the heart"—than the scene in which the heroic cross-dressed
Leonore stands alone and sings of the emotion which impels her danger-
ous attempt at liberation (both she and her husband, if he's still alive, may
wind up dead).

After the tumultuous opening of her recitative, Leonore's fear and
horror at the evil will of the prison governor resolve into a fervent real-

ization that the force which guides her is one derived from marital love but different from it. Her new understanding seems to come, literally, from the line of the melody which her fierce devotion discovers as it moves toward the realization that her only chance of success lies in the maintenance of yet another powerful emotion. That frail but—she prays—indomitable force is the pure light of hope. And so, as recitative merges into aria, Leonore invokes the power of hope in an arching plea which called out one of the highest reaches of Beethoven's gift. It proves to be one of those unadorned slow melodies that only he (and his young successor Schubert) could imbue with the beauty and the ongoing guarantee of meaning and reward which is what we chiefly seek in art, as we do in our lives (the two-syllable German word for *hope* is *Hoffnung,* and that extra syllable swells the sense of Leonore's resolution)—

> *... There shines in me a rainbow*
> *That rests brightly on dark clouds.*
> *It looks down so calmly, so peacefully*
> *It reflects old times once more*
> *And again my blood flows softly.*
> *Come, hope. Let the last star*
> *Not forsake the weary!*
> *Enlighten my goal, however far;*
> *And love will reach it.*

That comprehension on the part of Beethoven and his librettist—their realization that hope, "the last star," is an emotion which is always produced by another root cause—is a discovery seldom encountered elsewhere. On the contrary, hope is generally thought of as an instinct; and in humans, here at the close of a savage century (closing, as it opened, in genocide), the hint of hope in a work of art or on a human face is met in some quarters with incredulous grins.

But those jaundiced views would see hope as no more than a trigger component of the many-stranded animal instinct for survival and endurance. As Beethoven's Leonore knows, however, the truth about

hope is otherwise. The same hope which has kept the human enterprise sane — for those times when it's been sane — and which literally trans-figures the sound of her voice arises directly from the root of love; and the force of that love propels Leonore's fragile new-born hope to triumph over mountainous odds and eventually to free her husband from the dungeon a moment before his execution.

The animal determination to survive is admittedly huge and innate. All sane creatures appear to have a yearning to last and, unconsciously perhaps, to insure at least a genetic endurance through the propagation of further generations of their kind. But the birth and the strengthening of hope is a far more complicated, even sophisticated, transaction than the ache to endure. The urge to survive has no aim more specific than the blind continuance of an individual life.

Hope, on the contrary, always has a visible (if sometimes hazy) destination; and the distance or difficulty of that goal is no necessary dis-couragement. An ability to ignite and cultivate hope in our lives must be consciously taught to hopeless creatures and carefully learned by them, and its presence must be constantly invoked in every human life. For hope is born and dies by the moment, even in the most focused and opti-mistic mind. That's why one of the hardest tasks of a parent, a kinsman, a friend, or a sworn mate lies in the unceasing duty to pass on to younger or frailer creatures an undiscourageable taste for hope, "the desire and search for a future good." No one can rest in maintaining that taste in himself.

It's notorious that human beings are divided into those who see a glass as half-full and those who see it half-empty. Some genetically determined component may influence or even create any man or woman's proclivity to hope or despair; but however unconsciously manipulated we may feel our colleagues to be in their characteristic outlook, an in-teresting question to ask any one of them is Where did you learn to see as you do; who coached your vision? My own sense, from long observation and listening, is that most of us have that tendency formed — and all but

locked into place across our eyes like a wide lens—well before we've approached adolescence. Soon after infancy, we've unknowingly become either confident children, even over-confident, or we draw back early from the external world in silence and an excess of apprehension that is all but certain to last us forever.

A major debt is owed to any mentor who fostered hope at the edge of our cradles. Equally, resentment is owed to any doubter who fouled our vision too early to allow for later clarity. In most of the anxious doubters I've known, it's hardly been surprising to learn that the damage has come directly from a parent—from Mother more often than Father, if only because most of us spend far more early time in intimacy with our mothers than our fathers. Nonetheless, a single moment can clamp the desperate lens to our eyes—and that moment of childhood fright, that blighting word or sentence from a sibling or stranger, that glimpse of disaster tailored to our worst dread can come and vanish so quickly as to be invisible to any bystander.

Employing myself as an example (not because my life has been especially exemplary but because it's been mostly normal), I can say that from my own full memory, like most adults, I'm able to dredge up a handful of such lightning moments. And whether real or imagined, each is capable still of blowing a withering blast across my generally sanguine view. One such moment consists of a dimly subaqueous scene in which my young parents shout at one another a few feet away from my crib. Another is a sentence delivered by my mother's oldest brother as he taunted my recovering-alcoholic father and dared him to take "just one small nip." Another has me waking alone in an isolated pitch-dark bedroom, seeing the shadow of an escaped milk-cow beyond the window and knowing that the Devil himself had arrived to claim me. There are numerous other such memories of which I'm aware—some may well be fantastic creations without historical basis—and no doubt, if coaxed by a skillful hypnotist, I could find or produce from whole cloth any number of others.

My father, for instance, whom I saw no more often than the average child sees the average working father, was a steadily anxious man, calm on the surface and avid for laughter but deeply troubled at the core. One sign of his fear was an inability to leave my mother, my brother and me for more than a few minutes without kissing us goodbye; any parting might be the ultimate farewell. His three sisters always said that their mother had "scared Will early." She believed that her heart was failing; and each morning she'd tell Will to kiss her as he left for school since "Darling, we just don't know I'll be here when you get back" (in fact, she lived till he was in his late thirties).

My mother, on the other hand, had a grim right to view the world as a vicious cocked trap. Her mother had died of kidney failure when my mother was eleven, her father had suffered a fatal stroke when she was fourteen; and all her life, in her rare funks, she called herself an orphan. But till the moment her own brain flooded with ruptured blood, she was as filled with vivid expectation as my strong father was burdened by dread every day till his lungs filled with cancer and he died quickly — he at fifty-four, worn with strain; Mother at sixty, still eager as a young dog to hunt the deep woods.

She played a large part in smuggling that welcome but mysterious gift of hope to me. I call it mysterious because I remember no particular instance in which Mother ever instructed me in the virtues of a sanguine outlook. Indeed, among my strongest early memories of her, there are more than a few images of her lying on the living-room couch in the grip of what she could only describe as "a case of the blues." The anniversary of her father's death was a common occasion for a long blue day; she'd lie on the couch and repeat for me her memory of standing on the front steps and seeing a black worker from the Seaboard Depot pushing her father's dead body home on a two-wheeled mail cart.

But those brief pauses in my mother's prevailing vitality were overpowered for me by the far more common evidence of her deep-rooted hunger for life, more life. She craved it, above all, for chances at harmless pleasure; and among her notions of a chance at pleasure, she valued

few more highly than the opportunity to share with a friend some good or enjoyable thing she had in her keeping or could buy with our limited Depression-era funds—food, a pair of socks, a ride in her little car.

The simplest excursion to wade in a creek or to sit in the rumble-seat of her Ford and let her drive me and some child-friend to a dim cool creamery on the edge of town for ice cream cones while dusk settled round us and swarms of lightning bugs suspended themselves in the distance like what Mother called them, "Souls let out of Heaven till full night falls"—any such small joy could buoy her on till she saw the next opening onto momentary pleasure and rushed toward it before it could shut. I doubt she ever entertained the thought; but much of what she steadily did, for herself and those around her, was to work at building recallable memories, however small—and few of them seem small to me, even now, long decades after their causes.

The bent for hope—my hope and search, at least, for future good things—is built on nothing more substantial than memories. Good or bad memories almost equally: my hope of rescue from the harm those moments may have threatened, my fear of abandonment to them, whatever sense of a vengeful or a caring God goes with me by day and night, and the eventual trust in a purposeful guidance beneath my feet.

Why, though, should any sane child or adult accept such fragile and personal grounds for continuance? Again in my own case, I can only think I accepted my mother's lesson of hope because I loved her with the perfection that only a child can offer. In fact her nature was so filled with the promise of delight that I must soon have wanted to copy, indelibly, whatever I saw that was excellent in her, whatever visible parts of her nature had made her so rewarding and which might make me an equally magnetic creature whenever I moved into a world wider than her and my father's encircling care.

There were equal, or larger, parts of my father which I copied closely—his taste for work, his delight in mimicry, certain echoes of his voice and gestures, his ceaseless and masterful story-telling. But for

whatever reason, I chose early to omit the anguish Father suffered so steadily, faced as he was with no worse than the normal odds of life.

In recent years I've come to realize that another crucial aid in my acquiring the bent toward hope lay in another, and more tangible, kind of looking and copying. That aid came in the attempt to produce, on blank paper, a recognizable likeness of some part of the world that has caught my eye and demands to flow from my mind through my hand into meaningful lines outside my body. Even at their earliest and crudest, my drawn copies of things had at least a double aim. They were meant both for my own satisfaction and for the assent and praise of my parents. In those aims then, I was discovering, on my own time and with no more coaching than my father's occasional drawing beside me at the kitchen table, a need and a skill unique to *Homo sapiens* among known creatures.

In an early and difficult adolescence, I turned to still another kind of pictorial copying. My mother had always kept a simple camera; by the time my own interest in photography ignited, we had a rudimentary box Kodak—fixed focus and exposure—that got eight pictures to a roll of 616 film. And by the time I was into my teens, I flung myself eagerly into the vacant job of official recorder of family gatherings and vacations.

Sorting through the results, fifty years later, I see further proof that it wasn't family pressure alone that led me to specialize from the start in portraits of kin, friends, heroes and domestic pets. I was clearly searching for a lifeline out of my own young-adult sense that life was a trap with no sure escape routes. In fact, my only subjects which were not human beings, horses or dogs were the larger natural phenomena, such as mountains or lakes, and what I took to be historical sites—the house of a minor Confederate general or an undistinguished statue on a courthouse lawn (my childhood travels were severely straitened by the rationing of gasoline during World War II).

So for ongoing and still unexamined reasons, I was continuing my avid try at reproducing visible creation. As with my early drawings, even my first adolescent photographs were concerned to mirror what I per-

ceived to be "reality" and to mirror its manifestations as perfectly as prevailing light and my camera permitted.

What I think I can see above all now, turning back through the albums full of pictures from my childhood stint as a cameraman, is the fact that my eye and my hand virtually refused to choose a living subject whom I didn't, in some sense, prize or at least long for and plan to remember forever. A photograph for me was, and still is, an attempt at peeling a visible outer integument off memorable and swiftly vanishing faces and bodies. I dreamed, and continue to dream, of doing exactly what primitive peoples fear most from the camera — the painless extraction of enough of my subject's soul to remind me always of their precise feel and odor, the weather of their spirit when they and I are decisively parted.

Again, the final question raised by my own pursuit of realistic art — and the parallel pursuit of my whole species — is *Why on earth has anyone done this; why, despite a weakening in Western cultures of such ancient human impulses as parenthood and the instinct to gather in blood clans, does the making of accurate copies of human beings, other animals, inanimate nature and imaginary life show no sign of stopping?*

What do human beings — what did I in childhood — gain from our primeval and ongoing history of making tangible reproductions of other creatures, of natural objects and the works of mankind? What are paintings, statues, photographs *for?*

The presence of brilliantly rendered likenesses of mammoth and bison far back in the caves of our Paleolithic ancestors may have had religious, magical, entertaining, even educational significance for the artists who made them as long as thirty thousand years ago. The difficulty of access to many of the paintings, through narrow passages in bat-crowded darkness, suggests that the paintings were hardly idle jottings but were urgently purposeful projects of an entire people or tribe who focused their needs through the hand of one or more gifted and willing artists.

Whatever the no-doubt-broad array of motives and expectations that lay behind such copies, surely the overriding impulse was not irrecoverably exotic but tied to a hope for a bountiful slaughter of bison or

for better luck with weather, disease or childbearing. And surely the hope of pleasing whatever unseen powers the tribe acknowledged was a part of the purpose of even the simplest image.

Wasn't I, in early childhood (with little or no sense of a god or of transcendent help but propelled maybe by the same forces that had moved my Cro-Magnon ancestors), pursuing a parallel aim — the hunting down, with whatever aids I could find, of the heart's inexplicable desire, its unsleeping hope? I can confidently claim that a prime motive force was the sheer delight of my mind in discovering and contemplating a piece of the external world and my passionate will to possess that thing as nearly as possible, given my father's shortage of funds (a live elephant, for instance, was my main want till I was eleven; and Mother often said that, given the strength of my early longing and my father's generosity, she expected him to walk in some evening, leading a baby elephant). The intensity of that unnamed longing within me, even by the age of four or five, was surely the start of what has proved to be the chosen mode of hope in my life — watching the world at a safe but not secluded distance, writing my findings down on white paper in the walls of my home, hoping to see the world daily hereafter with greater skill, conveying that skill to friends and strangers, and wandering out into that real world in safety and strength whenever I wish.

Wasn't I, like any lucky child, working with all the remainder of animate creation to be my own instructor in the irreplaceable bent toward hope — a hope that was built on the assurance of love behind and under me? And wasn't I, like a great many children, learning of the possibility of hope well before I might need it in future straits and even before I'd had conscious time to choose among my parents' proffered gifts of confidence or apprehension? What I wouldn't see for decades to come was how thoroughly the gift of hope demands that we hand that same gift on to our fellows.

Long before I acknowledged that debt, however — during the last years of high school — I gripped down hard on a plan for my future, a

clear pair of hopes, though with no road map for the route toward them. I'd be a teacher of literature, who also wrote poems and novels of his own. Over the next decade I moved, with a good deal of stalled time in ruts and dense fog, toward that double end. By the time I was twenty-five, I was teaching English and American literature at Duke University; and when I was twenty-nine, I published a first novel. Only when I'd encountered a number of students (my first were mostly freshmen, men and women), and had begun to receive the kinds of nakedly confessional letters that some readers write, did I begin to see that, knowingly or not, I'd committed a sizable share of my time and my private force to the performance of an ancient public office. I'd brought myself to the unforeseen point where I was expected to be a local and sometimes-traveling firemaker, a passer-on of the skills of flint and tinder that evoke heat and light, how-ever briefly and prone to extinction and easily balked by failures in my skill and intent.

But since I have never married and have no children, except for a line of carefully made and uncomplaining books on a shelf, the recipients of whatever human capital I've managed to store are the students I teach every year and the strangers who choose to read my books.

In nearly forty years of work at both writing and teaching, if I've learned one thing about the export of hope across generations, it might be stated like this: *The expectation of something desired, the desire and search for a future good (difficult but not impossible to attain): each is transmitted, like most other virtues, from an elder to a younger human being through the passing on from one to another of a set of visible and deeply striking pictures. The pictures are generally mental images of actual pictures from human life and the natural world, originally beamed by simple light in a room or out of doors—or transferred in words from a verbal craftsman to a watchful reader—from the surface of one or more creatures or things to the physical or mental retinas of other creatures.*

It's the retinal or mental shapes themselves — even more potently than any words or sounds — that stand a chance of lodging in our minds

and slowly diffusing their meaning and influence over the choices we make when challenged by the questions of unshielded survival at the crossroads of life-or-death choice which we all reach in time. And the secret of why such images function so benignly and endure inside us, when eloquent words or the grandest music may vanish, must reside in the fact that the vast majority of human beings think and remember chiefly in pictures.

It would be possible for a skilled poet to fit different words to the eloquent line of melody that came to Beethoven at the juncture where his young Leonore faced appalling terror and turned instead, through love, toward hope. But such a drastic transformation is possible only if listeners had never formed, from Beethoven's original words and music, the picture that triggered such beauty from the composer: the actual visual image of an isolated young wife disguised as a likable boy confronting death to save her much-loved husband. For it's the simple picture, conjured by such complex means, that reaches us at the deepest level.

Joseph Conrad, the Anglo-Polish novelist, said with convincing precision that a writer's primary power lies in his ability to make a reader see; and that vicarious seeing, he adds, "is everything." All the emotions—hate, pity, joy and the rest—are transferable chiefly in whatever pictures can be made from words. Further, in Conrad's words, "art itself may be defined as a single-minded attempt to render the highest kind of justice to the visible universe." A writer's verbally conveyed pictures are his first and last hope, like a painter's crowded canvas, a chiseled relief of tribal war or sacrifice, or one of a set of photographs gathered around a central theme.

Except for a small minority of doubters and fearers, most human beings (alone in the animal kingdom apparently) nurture themselves with strong, though intermittent, hope. To be sure, some of them hope, in all times and places, for evil ends—the hopes of a Hitler, a Stalin, a serial killer. And a sizable part of the hope of even a healthy creature is for private gains—better food, more sex, the control of others. But most

humans have, often in their late years when pain and loss have all but felled them, a lucid stretch of days or years in which to note that an astonishing majority of humankind — kin, friends and absolute strangers — are capable of turning their own hopeful eyes onto someone else's solitary pain and acting to ease it.

Virtually every one of those creatures, if we could follow their magnanimity to its core, would reveal that they have slowly won that power to hope and to search for harmless good from the largely visual evidence which life sweeps past them in daily time and in handmade images. Those images are likely to confront us in remembered paintings, drawings, photographs, sculptures, buildings, the green and brown of external nature, and the infinite new potential of images made of no more than charged electrons flashed on a screen.

The present collection of photographs from various witnesses across the planet offers dozens of captive moments when men, women, children, plants, animals, rocks, the sea, the infinite sky appear to pause in postures of often reckless trust — two boys in a devastated lot in the Bronx, suspended in air in the midst of a game; a girl prepared for first communion, her face already opaque with mystery while a transparent younger sister stands smiling; a woman alone in a store-front church, rapt in prayer to an unseen God; a middle-aged couple who seem to dance by a tall row of trees on a bleak French day; an ancient woman warmed by bliss as the hands of an unseen friend comb her hair. On every page some image confronts us with evidence, however fleeting, that what we call the actual world is in fact the home of our whole species — our nursery and shelter, the familiar room or ominous cubicle or open space in which we meet the gifts and sudden trials of fate, seldom deprived of the traces of hope this lavish universe affords to eyes who've learned to search them out and hold them near.

Hope Lionel Tiger

It was not until Isaac Newton identified the Law of Gravity that an astonishingly important feature of the world was seen to be the natural force that it is. For many dozens of centuries people were aware that objects fell down, but now at last they knew the reason.

Water has forever been an intrinsic part of life. But it was not until the elements Hydrogen and Oxygen were discovered that their combination into water was recognized as an everlasting bedrock of nature.

The same surprising and sophisticated rediscovery of the obvious about nature has also graced our knowledge of the body. Scientists have discovered many of the rules of that dazzling electrical hubbub which is the brain and also many of the secrets of that ancient woolskein which is the human genome, the safety deposit box of our species' heritage. As the Nobel geneticist François Jacob said, "Everything that lives is also a fossil."

In the past we were a widely-spaced species in the making. Now we are a crowded thriving fossil in the flesh. We have prevailed for a very long time. One reason is another implacable fact of our nature: hope. I hope we will soon finally acknowledge hope scientifically and in the conduct of daily life for what it is: a central potent human experience, as essential to human life as water, as influential as gravity, and as varied and as interesting and omnipresent as animals, plants, and the movements of air and water.

Hope is all-pervasive and ambient in human behavior. Like air, only when it is absent does the centrality of its presence spring to consciousness.

Hope is to the brain what the energy from food is for the rest of the body. Hope is the context within which a decision of this very moment becomes a desirable outcome in the next moment or week or day or century. Hope is like gravity but it doesn't pull us down. It draws us forward. Into the future. Into the rest of this year or of our lives or beyond

the last rites. Into the lives of children and the destiny of their projects. Hope is a vital bias. It does not control outcomes but it leads to them and opens life to possibility.

If a master painter were to portray hope, it would require a new kind of cubism, with a different inner-outer dimension, with an unexpected kind of visual formula. Yet the viewer understands the work even without the new formula, because hope springs eternal and internal. Everyone has it to share. Federico Fellini once said he liked black-and-white films because when he showed a tree, the audience had to supply the green for the leaves.

The audience has the green to give. The same with hope, a currency we can create ourselves, to share, husband, estimate, to use as fuel.

Like light, hope flies where it is directed. It can be blinding as in teen-age love or too dim as in unemployment bureaus in fading provincial towns. But it is a universal factor in the human scheme nonetheless. It is a hormone of action so necessary, such an obvious element of behavior, that people and communities without it are like water without hydrogen—the physics doesn't work. Suicide, depression, immobility, the breakdown of civil order—these are hope-less conditions.

Hope is located first within the envelope of the skin. Artificial agents such as medicine and drugs are able to change how people feel about themselves and what predictions they are willing to make about the future. We had to evolve the capacity for hope just as we rose on to two legs because this allowed us to see farther, to chase prey and escape predators faster, and to rely less on the kindness of trees. Every day we had to assume we would evade a panther—that the day's work would provide a moderate reward for effort and then an evening meal and a night's sleep in front of the ancestor of the fireplace. Even at the time of Christ half the world's people were hunters and gatherers, which we all were for hundreds of thousands of years before then. If everybody every day awoke to say, "It's hopeless," there would soon be no tomorrow. To this day, every day, hopeful human energy generates the Birth of the Salesman, the night-school mechanic becoming a jet machinist, the large

or small entrepreneur saving today's money for tomorrow's return, the artist who creates an improbable square of color or words or hour of sound so that someone will cherish and admire it and return at least a meal.

Hope enjoys a special connection with the brain. We know drugs can combat depression at least temporarily. We know that some substances we create for ourselves produce hope. The endorphins we as well as other animals secrete reduce physical pain. Chemical pain-killers which can affect the substantial flesh of bodies can deftly influence ideas and moods. Everyday substances such as alcohol and sugar routinely do so, one obvious reason for their ubiquitous popularity. Robust exercise which is our birthright survival skill clearly improves physical health but also reduces depression.

The more scientists learn about the physicality of hope, the more we will be able to help people understand and seek the social conditions which fertilize it. Studying and learning about hope is an optimistic affirmation of the value of an intriguing gift. Even the endless morality play of sports fundamentally depends on the belief that X team or player will win; if they lose they will win next time; if they lose they were better than fate had intended; and when they win, rectitude and justice are everywhere established.

But hope is not only necessary for individual people or sports fans — it is a necessary vitamin or fuel for social process, and certainly for the most adventurous kind. Once I was in the coolly delightful Dutch town of Leiden where a plaque marked the location where the Pilgrims lived for twelve years before they made their unpredictable sixty-five-day voyage to America. It was sobering, startling even, to stand among those small brick buildings and try to re-create the deliberations and emotions of people who had already rejected England and now contemplated in intensely practical terms a punishing and dangerous sea voyage to an America they could imagine only imprecisely.

It was an immense matter, finally of immense hope, and it is therefore not so surprising that the country should have developed as a kind of

fountainhead of international optimism. Abraham Lincoln saw the Declaration of Independence as "...hope to all the world, for all future time." And of course for a long time indeed, people both within and outside the United States have perceived it as a scene of special openness, promise, and freedom of decent maneuver. Perhaps America's domination of mass media is not solely because of technology and astute investment but because as a society it reflects the whole human species, so rich is its ethnic tapestry. And it regenerates this experience of variety with an odd alloy of innocence, hope, action, and candor. Its films, music, and even seemingly vacant television products such as "Dallas" and "Baywatch" somehow find extraordinary worldwide resonance with foreign people who presumably feel they gain an inch or two on life from their experience with these art forms.

There has been an exhilarating unfolding through science of the mystery of the inner life of things and beings on our planet. This has yielded a substantial change in what is known to be true. Is hope to be challenged too? No. As the theologian Moltmann suggested, hope takes up where faith falters. While hope is secular it is nonetheless vital to enterprises of life which may be essentially spiritual.

Someone must attend to the range of experience which realizes hopefulness. Often it falls to public leaders to provide this vital ingredient. However, in the nature of their work it may be necessary that they embed themselves in the grainy banality of day-to-day life. The music for the aria of genuine large-scale hope may be mislaid under plans for power dams and play centers, troop movements and the export of hardwood trees.

Nonetheless, now is that "all future time" of which Lincoln spoke in his speech in Cleveland in 1861. Before the Renaissance, leaders could succeed by claiming they had the map back to the Golden Age of the past. Now they must boast they can benignly coerce the future. Even if they have no coherent or plausible plan to avoid decline or disrepair. Even if the population endures a sense that life is like sandpaper, not silk or even rayon.

The world must encompass more and larger social and economic trends than anytime in the past. It has never been more important to confront these tumultuous forces with strategically reasoned practicality about the recurrent importance of work and money as well as with deft response to the inevitability of change. This agenda must be embraced with hopefulness about human life. It appears time for a new environmental movement, not only about the outdoors and nature but the inside of the body and human nature. People flourish when they feel hope in the neighborhood and when they feel it in their bones. Inner and outer hopefulness require protection — tender, firm, perhaps even fierce.

Steps, Leaps Robert Coles

All the time, physicians who work with children see hope enacted, hope put to words, though the words themselves may not stay long in their busy medical minds. I remember working with boys and girls who had contracted polio in the last epidemic of that disease in America, just before the Salk vaccine came into use. I was a hospital resident in Boston, learning to be a pediatrician, and every day we in the emergency ward were admitting youngsters who suddenly found themselves unable to move their legs or their arms, and in some instances, unable even to breathe normally, effectively. Such a daily experience can wear down young doctors—after all, we had no cure, could only put the patients with breathing difficulties into respirators (then called "iron lungs"), and with the other children follow helplessly the course of developing paralysis. Many of those boys and girls, only a few days before in blooming good health, would be seriously crippled for life. Yet, many of those young patients refused to view their situation as we attending doctors did; rather, they kept telling their parents, brothers, sisters, friends, and us in the hospital that they were going to "make it," that they would be "all right"; and not rarely, they surprised us, sometimes stunned us, by their capacity, their willingness not only to think well of their own prospects, but to try boosting the morale of their families, their neighborhood pals who had come to visit them.

Not a few of those young polio patients even went further, agonized out loud about the effects of their illness on others, their loved ones. I remember one such child, a boy of ten, who knew how much pleasure his father got from watching him play baseball, and worried hard and long about the dad's disappointment, the real sense of loss he'd experience. I remember a girl of eleven who had become so very helpful to her mother in the care of her three young sisters—she kept telling me how concerned she was for her mother, for her sisters, how determined she was to try to continue to help out, down the line, in the care of those little child-

ren to whom she'd hitherto been so connected as her mother's "assistant," she called herself.

Of course, we young doctors were no strangers to the psychiatric aspects of illness — when we heard boys and girls like those two speak with such idealism, such high-minded concern for others, we wondered whether, in fact, a considerable amount of anxiety wasn't being "displaced"; children who were really worried about their own prospects were shifting the thrust of their concern toward others, in a kind of "denial" of the obvious reason they had to be alarmed, if not saddened, by what had befallen them. Indeed, so many of those boys and girls kept telling us that they were going to be all right, that they would "win" in the long run, "beat" the illness that had so obviously taken hold of their limbs, changed the way they lived their daily lives, that one day, a group of us hospital residents sought counsel from one of the older pediatricians, who had spent a lifetime working with seriously ill, hospitalized children. We kept telling that doctor how concerned we were for the psychological condition, never mind the physical situation, of our patients — they seemed utterly "unrealistic" about their future fate, a measure, surely, of the extent to which they were burying their heads in the sand. But this experienced clinician didn't see the children's behavior as we did; on the contrary, he was unsurprised by it, and he had no interest in regarding it as evidence of psychopathology. Rather, he told us of his observations over the years of sick children — how they came to terms with the pain, the inconvenience, the limitations imposed by illness, and alas, sometimes, the threat of an early end to life. He had actually specialized in the care and treatment of boys and girls who had fallen victim to various kinds of leukemia, and so he knew firsthand how those young people dealt with death as a distinct, near-at-hand possibility. I can still remember what we were told, a response from a veteran medical warrior to us fledgling, but not so humble or modest, combatants: "These kids know the score. They may not tell you (they may not tell anyone) that they do, but they know in their bones what's up — and it's in their bones that they also know what to do, how to fight for their lives."

He was being rather too vague or elusive for us, and he realized that was the case from the looks of perplexity (if not outright skepticism) on our faces. A tape recorder was whirling around, and for that reason alone we felt the need to prompt him for amplification — though, really, we had already settled into the smug posture of those who are ready to dismiss someone as "over the hill," even as they have little doubt about their own, important futures. Soon enough, we heard this: "You folks want more 'realism' from those children. You want them to admit to you that they are worried about what's happening to them; that they are frightened out of their minds, maybe; that they are so nervous and sad — well, they try with all their might to look the other way.

"My hunch is that you'd have no trouble getting a lot of our patients here [on The Children's Hospital ward, where we were sitting in a room that adjoined the nursing station, with its twelve or so charts of a dozen seriously ill young ones, all under the age of twelve] to nod their heads willingly, and say, yes doctors, we're about as sick as you can get, and still be alive — so, what's new! But what you *would* have trouble hearing from them, is how precisely they have taken stock of their situation, and how shrewdly realistic they are about what they can and cannot do on their own behalf. These are not patients who are escaping from the truth of their condition, as you all think. They are patients who are fighting to stay alive, rather than patients who are dying — that's how they think of themselves; and they also think of themselves as realistic, utterly so. Let me tell you why: It's their only hope, to be hopeful."

What in the world did he mean by that, we wondered silently. He quickly read our faces, however — and so, then this: "I don't mean what you think I mean! I'm not talking about 'hope' as something silly or fatuous or naive or sentimental, and I'm not being clever, either. I was trying to get us all down to fundamentals — and of all fundamentals, hope is the bottom line, No, it's no 'psychosomatic medicine' I'm talking about. [One of us had wondered whether he was trying to tell us that if the children were more optimistic, they might in some way, for some mysterious reasons that still were not known to us, begin to recover, or at least, do

better in their struggle—meaning, last longer, and be stronger for more weeks or months than others less upbeat.] What I mean is this: It's in our 'blood,' our very nature, to want to stay alive, to want to keep going, and that's especially true of children: why, the whole world is out there waiting for them, a world of time and of space, and of possibility. So, they are hopeful even when you docs and I aren't—that's what we need to remember: We need to respect this side of them; we need to be realistic about their hopefulness rather than turn them into psychiatric cases!"

He was a physician who constantly, for decades, had been on the front line, where the struggle between life and death takes place, and as a result had learned a lot not only about his patients, but from them—the impact, really, of extreme jeopardy on the mind's life: hope as not only the ordinary expectations that reasonably healthy people summon, but the last-ditch defense of small children who are on the ropes, yet still trying to stand, to jab away, as best they can, against the terribly elusive diseases which have beset them. He saw hope as the defining aspect of our humanity, not only as emotion, or state of mind, but something, again, that goes to the very heart of our nature: a biological expression of our insistence that we last as a species, and as the individuals who belong to it.

Now, many years later, I often think of that teaching encounter as the moment of truth it obviously was, but also realize its prophetic quality—as I read medical journals, and through them, begin to understand the biology of hope, the neuropsychopharmacology of our emotional life. Increasingly, we are beginning to learn how the brain works, the discrete and specific nature of its various clusters of cells, the neurochemical nature of its functional life. We are learning, for instance, about the cingulate gyrus, located well under the brain's substantial cortical surface—an arch of sorts that extends from the front to the back, a place of great biochemical and physiological activity that has a bearing on how we attend the world and with what kind of disposition or mood. We know now that medications meant to alleviate the subjective side of depression (the felt gloom and sadness that accompanies spells of frustration, in-

capacity, vulnerability) prompt changes in the metabolism of the gyrus. Quite literally we can thereby document a person's response to certain antidepressant drugs — an increase of neurophysiological activity, to the point that one wonders whether melancholy in some way "resides" in that gyrus; and its opposite, as well, the hopefulness that is also, surely, going to be accessible to our increasingly sophisticated ability to observe and comprehend the brain's microcosmic activity.

We know how to capture visually this kind of cerebral energy — courtesy of the psychiatrist Monte S. Buchsbaum's work. We can study it as it takes place, represent it for others to behold. To use the language of science, the metabolism of the human brain can be rendered through positron emission tomography, known as PET scanning. A radioactive analog of glucose (which is the brain's source of energy) and a ring of crystal detectors can be used to produce a colored picture of neurological activity. Particular thoughts and emotions prompt their very own, specific pictures. By combining such (PET) scanning, with its glimpses of the brain's functional activity, with magnetic resonance imaging (MRI), which can offer a detailed picture of any organ's structure, a scientist can select a part of the brain for study, and too, for a kind of rendered visual display: a landscape of human subjectivity now becomes an aspect of shared objectivity, with the scientist or viewer able to witness what is within a person's "head." Such an outcome is a consequence of a kind of inquiry that is at once scientific and artistic. The images that emerge from PET scanning and MRI imaging get joined; and computer graphic methods enable a three-dimensional representation of this or that "area" of the brain — places where, collectively, the mind's life is housed. In this particular instance, that of the cingulate gyrus, we can become observers, as it were, of a room of sorts in the larger residence wherein dwells our humanity — a room that, again, connects our cognitive life to our emotional life, our conceptualizing self to our feeling self: an arch of hope, and too, when things go awry, an arch of despair. Eventually, it is safe to assume (I hope!) that the extraordinary and knowing subtlety which informs this kind of research will help us comprehend what makes

for the difference — what enables hope or edges us toward gloom, and by extension, what allows mental competence, strength, or makes for psychological disorder, disarray.

I do not think, then, that we are too far from an understanding of the biology of hope — that short, four-letter word, surely a shorthand way of invoking a rock-bottom determination on our part to survive at all possible costs. In a sense, all of what we are is connected in some manner to this primary agency, so to speak, of our being — because hope enables faith and love, the two other "graces" of the well-known Biblical threesome. Indeed, hope enables our entire emotional life — which requires some inner (I mean genetic and physiological as well as psychological) conviction on our part that we ought to hold up a future for ourselves, the immediate personal one each of us has, and the larger one that is the sum of all of our experiences, as we have tried to sustain ourselves over time: the survival of our species. Nor is it stretching a point to regard hope as essential to that Darwinian notion. Survival has to do with the daily exertion of an organism, lest it starve, perish. Such an exercise, be it at the "level" of reflexive muscular-skeletal activity, or that complex mix of contemplation and willed effort that is a hallmark of humankind's exertions, has to do with some sense of purpose, some notion, embedded in protoplasm as well as (among us) in thought, that energy expended will be to some effect, and those last three words (that what happens can be, might be, must be, to some effect) constitute the very heart of the matter with respect to hope, as insects show us, in their vast microcosmic affirmations, tenuously pursued, and as birds do, as they circle and circle, ever watchful, ever anticipating, ever true to nature's rule, which embodies hope's enormous circumscription, its broadest rendering: seek and ye shall find — an injunction worked into countless genetic codes long before the Biblical moment which that exhortation evokes in the memories of some of us.

No question, of course, we who use words and know of things as no other creature does, have our own extraordinary versions of hope — the brain's "mind" whirling with yearnings and reckonings and calculations

that seem, at times, limitless, even as they inhabit each one of us, never mind the collection of us who constitute a family, a neighborhood, a nation. It is as if each of us has his or her own lookout destiny: the particular sightings we make of what seems desirable to us — and, thereafter, the actions we take to make what is spotted, ours. Put differently, hope's complexity skyrockets, so that nothing less than a grasp of all space and time becomes our aim: the astronomer with a telescope searching into the infinity of the universe, seeing the light of numberless millennia, of eons whose duration even surpasses our effort at rational or imaginative comprehension. Alternatively, closer to our planetary home (indeed, within its very bowels), the archaeologist digs, ever so scrupulously, gingerly — years spent among the ruins, sifting rubble and dust in a similar determination to overcome the barrier of the past, penetrate its secrets, bring us all closer to what was, make such knowledge a part of what is. Those postures, of peering upward, of poking downward, tell us a lot about who we are as human beings, tell us about our restless desire to explore, but also about the Promethean fire within us: We aspire to turn all nights into days. It is this unquiet within us that runs in our blood — a blood that psychoanalysts call our "drives" and biologists our "nature." We are attuned to people, places, things, we get interested, excited, fascinated, entranced: the stages of our hopefulness, the degrees of its intensity. For hope is, finally, the instrument of our survival, our endurance, as those polio victims knew far more explicitly, consciously than we young doctors knew — so our elder advisor, our pediatric guru, knew to whisper in our ears.

No wonder, then, the wide range of these photographs, and no wonder, too, the different potential takes on them, on the overall idea that informed their selection. A person's eyes roam the world of photography, light upon certain pictures which engage the mind, stir the heart. Over time those photographs begin to join one another's company in the mind of the explorer, the seeker, the collector — a number of objects lose their particularity, become parts of a larger picture, a binding notion, if not a vision, called a collection. Those who have been the collector's allies have

their say, tell of what has happened—they are compatriots, their eyes prompted by his, prompting his, the mutuality of the search (maybe even the shared pilgrimage). Others are approached, asked to look outward at the visual images, inward, too: how to fit their own, personal experience, their acquired knowledge, their vocational competence, to this assembled scene—and soon enough, their statements, antiphonal replies to what has been done: the looking and choosing its own song, and further along, in the same vein, the viewers at a gallery as additional participants in what becomes an ode to human possibility, to the range of our expressiveness, our intentionality.

Such a pictured breadth of things deserves the directness of designation that goes with the word *hope,* its inclusivity, its relentless, pervasive connection to life itself as it gets asserted in so many and various ways. Feet dangling, machines working, horses bounding high, lovers meeting, looking, embracing, athletes flexing themselves, or ordinary people doing likewise, men and women and children at rest, at work, at the table, on the move, holding flowers, riding bikes, reaching for one another, launching rockets, working with machines, gambling, playing on the city's streets, frolicking in the countryside, leaning upon one another, going resolutely their own ways, praying hard or drinking hard, with doubt and misgivings thereby held off, however momentarily: all of that, animal, vegetable, mineral, has to do with the continuance of this earthly life; and such is the stuff of hope—the willingness on our part to dare to expect (and try to further, to work on behalf of) that continuance. So doing, we walk and run, stumble and fall, but (hope against hope!) get up again; so doing, we survey the land, the workings of the body, the depths of the earth and the farthest reaches of the sky. So doing, we try for love, exult in its presence, welcome and nourish its gifts, what it enables in us, helps us to become, and not least, what it does for others, for the future—which is our children, our children's children, the edge on time to come that each generation struggles to sustain through genes given yet another roll of the dice, and too, through beliefs and values and ideals and aspirations and cherished memories and long-practiced

routines or rituals, all handed over, handed down to a posterity that sheds light on the darkness, even as these pictures, it can be said, shed light on that light, with hope thereby grasped from the midst of its being, its daily incarnation or realization, and held up to us: ourselves returned in all our amplitude, our shades and modulations of gesture, tendency, aim, ambition, wish.

Hope is, at the start of life, the infant's eyes finding in a mother's eyes, a dad's, the welcome, the affirmation and confirmation that go with such a linkage of flesh, of generational commitment and responsibility to generational possibility and requirement and susceptibility. Of course, there are other versions of the above: the infant as the one who reassures; the infant, even, as the one in command, as every parent who has heard a baby cry will remember—that baby's hunger or hurt becomes a clarion call, a summons whose import is vast beyond measure, with everything at stake. Such is the grounding of hope; its genesis is in a faithfulness of parents that plants and tends and nourishes faith in the child— a faith that time builds, a faith for which space offers itself so that there can be experiments, play, the testing and teasing that go with life come to terms with matter, with floors and objects, and porches and steps and the waiting ground below: the incarnation of hope in the daily explorations, the rhythms of curiosity, discovery that go with (indeed, constitute) childhood.

Further along in life, there are impasses, hurdles, falls—they, too, are part of the story of hope, as Darwin knew on the grandest level, and as every boy or girl learns as a wish gets tested by one or another kind of wall. We learn, that is, to hope through defeats, as they come our way; we learn to know our limits by the testing of them—and thereupon set our limits anew. This adjustment of expectation and striving to accommodate particular circumstances is actually what we young doctors were witnessing back then on that pediatric ward—with our teachers those children whose thwarted limbs only inspired rather than diminished their hopefulness. "You see, I can do it like this," we kept on hearing from children who, against considerable odds, were becoming newly inven-

tive, ingeniously improvising, cleverly original in the way they took care of their bodies, tried with them to deal with the suddenly serious obstacles that the distance of floors, the presence of furniture, rugs presented. "I got there," we heard—with the same gusto, we only gradually learned, the pioneers, discoverers have expressed upon seeing for the first time new places, continents, planets, whether by land, sea, air, or yes, courtesy of a lens. "I may not get there with my steps, but I'll leap there with my mind," I heard a twelve-year-old girl say once, as she contemplated with utter candor and realism her own incapacity, yet paradoxically proclaimed her quite evident ability, nevertheless, to arrive at a given destination. There was hope to its core, the leeway that a mind's leap can provide—the creation, actually, through the imagination of a new kind of reality. Again and again, those polio-stricken children made that point to us, taught us the lessons of hope, its silent, unobtrusive life within the mind, its lived realization in dreams, in thought.

"I sure hope—I hope with all my heart—that when my body is ready to go, I'll be ready to see it go, say good-bye to it and everyone else I've known all these years"—so I once heard William Carlos Williams say, toward the end of his time here on American soil. (He was born and died in Rutherford, New Jersey.) Even with very little time ahead, and with the pain, the limitation left in the wake of heart seizures, strokes, cancer, a fiery spirit lived within, trying again and again to put the magic of poetry on paper, to sing for readers, but trying also to bow out at the right time in the right way—a final hope, it was: for a departure with dignity, a good-bye that leaves others remembering fondly rather than tearing their hair out, shaking their fists. As it happened, the Doc, as some of us called him (no matter his clear efforts to get us to call him Bill), died in the morning of an early March day, his faithful dog, Stormy, the first one to understand his leave-taking. Weeks later, his wife, Flossie, told me this: "Bill died as he hoped he would—I was so glad for him." Hope at the end, even as there is hope at the start: the baby's first cry, a signal for all to hear, mother and delivering doctor and enormously helpful attending nurses, that someone has just arrived on this planet,

possessed of (in James Agee's memorable phrase) a "new and incommunicably tender life," whose vicissitudes will most assuredly arrive soon enough, yet whose determination and pluck are an utter potentiality, only awaiting the world's encouragement in various and kindly ways.

Here, then, are a hundred glances, direct and sidelong, of what some of us have come to regard and treasure (and now, want to share) as hope; here is hope noticed, gathered into a visual collection—hope selected, arranged, displayed; here is hope considered by a social scientist, a novelist; here is hope caught in its assertions, implications, suggestions. We who for a moment become spectators, readers, are invited, ultimately, to become companions to these pictures and words, sharers of a message—that from our initial moments to our last ones, we have it within us to make our various connections with this world, take thereby our steps and leaps, literally or symbolically or plain expressively: the mind's dream or fancy, the heart's, the soul's outcry, even the stomach's growl in an infant become its raw, strident bellow—hope the language of our human energy as it strives, always, to find the waiting, willing eyes and ears of others, the acceptance that goes with one person paying another heed.

Camera Works was formed to help illuminate and preserve the series of changes promising to transform photography in the next decades. Its goal is to collect, display and publish the strongest work being made by creative photographers today, as well as work that most powerfully incorporates and describes the inevitable technical evolution of the medium.

Today the practice of picture-making stands at the brink of a momentous era comparable to that precipitated by x-ray a century ago. Biomedical researchers now observe the "inner universe" of ourselves as never before, evoking the promise of earlier diagnoses, faster interventions, better medicines, healthier lives. They are beginning to see, in the brain, where our emotions exist, and the early signs are that the immune system substantially weakens with despair and significantly improves with hope. There is a biological reason, after all, why hope is the most-used word in the human language.

Homo sapiens have always known instinctively that a hopeful outlook can make a decisive difference in well-being, but that ancient wisdom is now being confirmed. Given the progress in brain-imaging expected over the next decade, it should be possible to see and show — scientifically — that the healing and regenerative powers of hope are real and can be used to our advantage. Anticipating this future knowledge, the collection of *Hope Photographs* celebrates it in advance.

As creative photographers join with scientific image-makers on a common ground of technology, a revolution in photographic practice lies just ahead. Camera Works is committed to supporting and conserving these transformations as they unfold.

Acknowledgments

We want to extend our thanks to the photographers in this collection for visualizing what we saw as hope, and to the writers of these essays for exploring the subject in words.

When we first made our calls, photographers, galleries, dealers, and agencies responded to our surprising request by wholeheartedly joining the pursuit of this elusive, and very subjective, subject. Many images were considered. Many discussions about the meaning of hope followed. In the end, whether in the final selection or not, we want to thank all those who participated and made this project a pleasure.

We would like to thank Hans Werner Holzwarth for his indispensable help in making this book. His design, his production savvy, his friendship — all were essential.

Also particular thanks to Margery Bassett, O. Aldon James, Jr., and The National Arts Club for exhibiting the collection, and to Curatorial Assistance for traveling the show.

Patti Sabatino, Richard Gien, David Sternbach, and John C. De Prez, Jr. helped in special ways.

Without Camera Works, Inc., this collection would not exist. To it, we owe our greatest thanks.

A. R. G. & L. M.